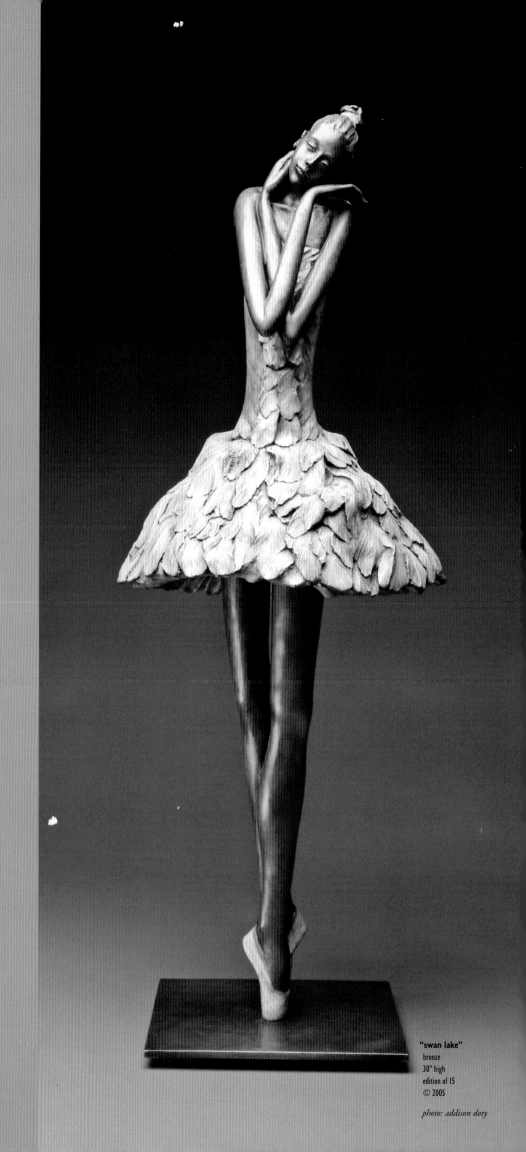

david

d a v i d + **pearson**

pearson

"swan lake"
bronze
30" high
edition of 15
© 2005

photo: addison doty

Publisher
Fresco Fine Art Publications, llc
frescobooks.com
All artwork ©Pearson Studio, Inc.

Design
Lowry & Associates
www.lowry-associates.com

Photography
Addison Doty
Jim Alford
Bob Smith
Donna Rokoff
Dana Tincher
Richard Faller
Peter Kahn
David Hoptman
Nancy Napier
Doug Coffin
Robert Reck
Patricia Carlisle
Scott Lowry

ISBN 13: 978-09762523-2-0
ISBN 10: 0-9762523-2-5
Library of Congress Control Number: 2005935939
Printed in Italy

patricia carlisle fine art inc

554 canyon road, santa fe, new mexico 87501
toll free 888.820.0596 • www.carlislefa.com

david + pearson

the path of a sculptor

I would like to dedicate this book to my lovely wife Patricia –
We walk together!

table of contents

d a v i d + **pearson**

Contemporary society focuses primarily on the future. The past and present are often forfeited. Success is measured by material worth rather than integrity and virtue. We have lost our connectedness to each other and to nature. Life is too often turned up to high volume and running at full speed. How do we recover a more tranquil, reflective time? David Pearson's work is a recuperation of this loss prevalent in contemporary culture. Pearson offers an alternative experience, a new perspective. He allows us the pensive moment to be there, to rethink the frantic pace and speed of our time, to reflect on the past, and to embrace the present moment.

Mysteriously elegant figures that haunt reality and delicately take form as they transcend from the imagination, give tangible credence to the poetic and mystical realm of Pearson's vision. A vision uncluttered by unnecessary detail and extraneous matter. Pearson creates the pristine essence of the human body in which gender, age, and race are eliminated and replaced with the purity of gesture. His is a clarity of vision that reveals the gestural unfolding of fragile emotion and innocence of thought, a sensibility that allows us a portal into a space beyond reality and into a realm of repose and harmony. His is a theatrics of timelessness, a poetic staging of the imagined lives we long for.

Pearson's figures come from an ancient place, another time. An angel, a muse, a goddess, a nymph, a mother, a dove, appear as if out of a dream or myth. They come to give counsel, offer direction, or simply to recall the pure beauty of human interaction or to glorify the stillness of nature. In the company of these mystical beings we are transported to another place, a peaceful time, an intimate moment. Time is crystalized in their gesture, their thought, their presence. They are embodiments of introspection and meditative calm.

photos: bob smith

It is not unusual that Pearson's studio and home are surrounded by the serenity and natural beauty of New Mexico's desert. It is this environment that inspires the introspective quality that his work exudes. Nature, birds, land, stone, sky — all take shape in the work. The physical beauty and spirit of nature, and the clarity of the landscape, are manifested in Pearson's thoughtful use of graceful line, flowing form, rich texture, and luminous surface. Earth as clay is shaped, metal is transformed, ephemeral life is made bronze. He unites human form with natural abstractions — the body becomes a tulip, stone, earth. Faces are intent on the present moment, drawing attention to reflective thought. The graceful elongation of torsos and limbs echo the expansive line of the horizon that delineates Pearson's New Mexico home.

Pearson's experience began at Shidoni Foundry in Tesuque, New Mexico at the age of 15. He began sculpting at 16 and for 20 years he cast works for such sculptors as Allan Houser, Linda Bengalis, Terry Allen, Kiki Smith, Bruce Nauman, and Luis Jimenez. In spite of the many sculptural influences, Pearson has keenly developed his own style, technique, and repertoire of imagery. In a strong tradition of contemporary figurative sculpture, he is part of a lineage headed by such modern masters as Aristide Maillol, Alberto Giacometti, Henry Moore, and Allan Houser. The work of Allan Houser has been a significant influence on Pearson. Pearson's figures, like Houser's, embody a sense of inner peace and contemplation.

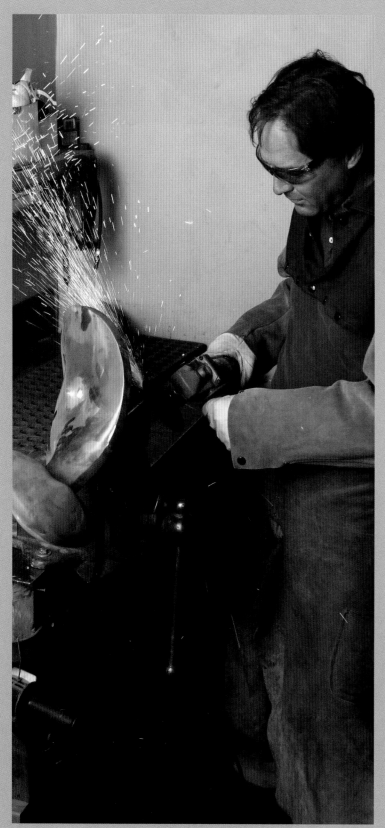

photos: bob smith

In his thirty years as an artist Pearson has been exploring the transformative process of metal. Few sculptors are as intimate with each process as Pearson, whose hand and intention shape each step. He finds creative energy in each literal transformation of material: from hand to clay, to creation of the mold, the wax, the casting, the burnout, the pour, the chasing of the metal, to the final completion of applying the patina.

Pearson's patinas are exquisite, highlighting color and texture to create a sensuousness of form reminiscent of sculptures of the ancient cultures of Egypt, Greece, and Italy. Pearson's sculptures incorporate the calm, the dignity, the fullness of the human body masterfully realized. They are often lavishly draped in sheer flowing garments that accentuate and enhance the voluptuousness of shape and contour. Sleek and slender they stand like pillars of radiant light, tenderly engaging our senses and marking our sense of time and reality.

Our concepts of reality, truth, and beauty are constantly changing. Many artists work reflect these changes. The continued disruption and intrusion of technology into our land and lives, and the collective experience of heightened anxiety, skepticism, paranoia, fear, and hysteria, are symptoms of larger, cultural, economic, and social systems collapsing. These conditions shape thought process, means of expression, and quality of life.

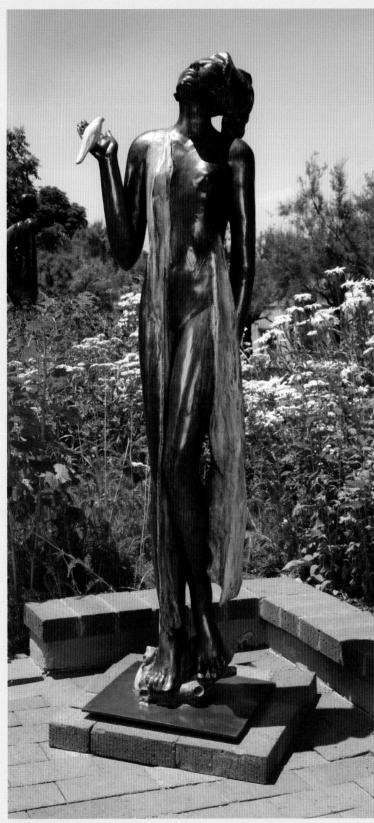

"ascension of eve"
bronze
57" high
edition of 15
© 2002

photo: addison doty

For decades artists have been creating metaphors of the human condition, challenging preconceived notions of beauty and truth and offering new perspectives, vision, and hope for change. Art offers a chance for reflection, meditation, and recuperation. A work of art can provide solace and retreat from the hurriedness, the havoc, the horrors of today's society.

For thirty years, Pearson has followed his vision, trusted his heart, and respected his medium. Through experience, he has come to know his medium intimately. In his manipulation and redefinition of the material, he continues to explore the physicality and lustrousness of surface and its ability to reveal inherent qualities of beauty and truth. Beneath the surface there is hope for change, a chance for hope.

David Pearson does not aspire to change the world with his art, but rather to change people individually as they respond, interact, and reflect on his work in an intimate way. He transforms clay, then metal into incarnate thought. Something profound is portrayed and communicated. Through him we glimpse the truth of the human condition, the beauty of the human body, the spirit of the natural world, and the graceful wonder of their embodiment in bronze.

Cynthia Sanchez, Ph.D.
Director, Capitol Art Foundation
Curator, Capitol Art Foundation
Santa Fe, New Mexico

c h a p t e r 1 **new mexico raised**

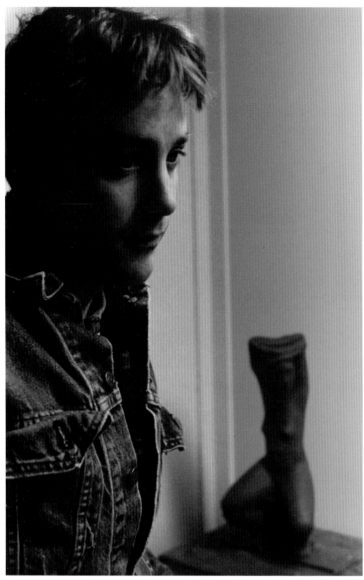

photo: donna rokoff

*David–around
20 years of age
–in his studio.*

The autumn equinox, which divides day and night equally, is considered a time of mysteries, a time to honor the spirit world and give thanks to the waning sunlight. The Druids once recognized The Green Man, or God of the Forest, by offering libations to trees on this late-September holiday. It is a time of equality and balance, of harvest and prosperity, often represented symbolically by wine, gourds, pine cones, apples, pomegranates, vines such as ivy, and marigolds.

It is a good omen to be born on the autumn equinox: it suggests fate has plans for you. This is when sculptor David Pearson came into the world. Born on September 20, 1958 — on the cusp of perfectionist-oriented Virgo and beauty-absorbed Libra — Pearson has always felt a sense of destiny, and a connection with a greater life force. "A lot of times, pieces just come through me and when they're finished, I can't believe I made them," he says of his ethereal sculptures—transcendent bronzes with subtle spiritual references, most often shaped into elongated female forms, mummies, and one-winged angels, and sometimes accompanied by doves and finches. "You've got to touch people. That's why you create art: to touch people. I want to touch them in a way where they find some deep emotion inside themselves that they've hidden away, and the sculpture brings it out so they can access the emotion."

Pearson spent his first eight years in Tucumcari, New Mexico, a ranching town in eastern New Mexico where nature surrounded him. He remembers, "It was middle America. Big, wide streets. Nice houses. Everyone had a boat because Conchas Lake was 30 miles to the northwest, and Ute Lake was 30 miles to the northeast. It was a wonderful place. Very safe. I had all my aunts and cousins, and a feeling of totally belonging."

Born the middle child, Pearson wouldn't have heard much talk about spirits and Druids in Tucumcari, but he did develop a Southern accent there like everyone else so close to Texas, and he was always fascinated by ancient civilizations — including those of the Southwest. "I remember being about six years old and going out with my uncle and the rest of the family hunting for arrowheads. We would do that twice a month, just go somewhere. I loved that, visiting the old Indian ruins," he recalls. "I was always into the mystery of, 'What was it like for them?'"

"prudence"
bronze
36" high
edition of 15
© 1976

photo: dana tincher

The first piece David created.

Fate fingered Pearson out of this rural setting at age eight. "Tucumcari died because the railroad moved out overnight and took 20,000 people with it. Their hub had been in Tucumcari and then it went to Amarillo," he explains. So his parents moved the family to Santa Fe, four hours away in northern New Mexico. In the more bohemian capital city of New Mexico, artists' studios were everywhere and suddenly Pearson was in their midst. "I don't know if I would have said that I had talent, but I was always, always looking at books and at art, and seeing art in other people's houses. It was a calling. Some people buy a piece of art and never look at it. And me, I was just drawn to them," he says.

It wasn't long before he demonstrated his own artistic aptitude. In the Casa Solana neighborhood of Santa Fe where he matured into a teenager, Pearson remembers getting his first professional art assignment: he drew illustrations for the newspaper at Santa Fe High. This was in the open-minded late 1960s: "Easy Rider" was filming along the Rio Grande River for its 1969 release, and summer séances were being mounted by inquisitive teens along Pearson's block. It seemed like anything was possible as a counter-culture came of age, with rock-and-roll as its anthem. "We

"reflections"
bronze
4" high
edition of 15
© 1976

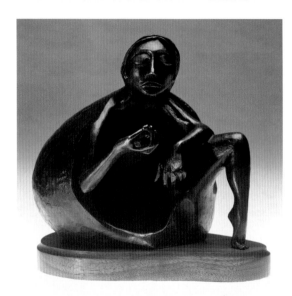

"the jeweler"
bronze
6" high
edition of 15
© 1976

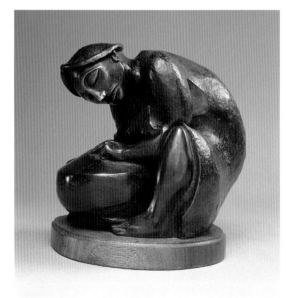

"the potter"
bronze
6" high
edition of 15
© 1976

photos: dana tincher

were listening to Southern rock bands like Lynyrd Skynyrd, 38 Special, the Allman Brothers. I've always loved music. Those were good days." Pearson remembers.

Pearson, who went by the nickname Rainbow for a while in these free-spirited times, flourished in experimental classes at Santa Fe High School, like horticulture and electronics. "We were in this huge room with these big tables surrounded with all these gadgets—soldering irons, flow meters, TVs stacked with resistors. You had 30 minutes of structured class with a teacher, and the other two-and-a-half hours you got to work on TVs. God, we were in heaven. You could go outside and smoke a cigarette. You could go down the hall and get a cup of coffee. We were like adults in 10th grade. I had long hair. I guess you could say I ran around with the hippie head-banger group," he recollects.

It was an open-minded atmosphere that cultivated creative expression. "Totally free and caring," is how Pearson puts it. "I fared really well. I didn't have a lot of hardships. My whole life has actually seemed very simple for some reason. It just flows without too much hardship."

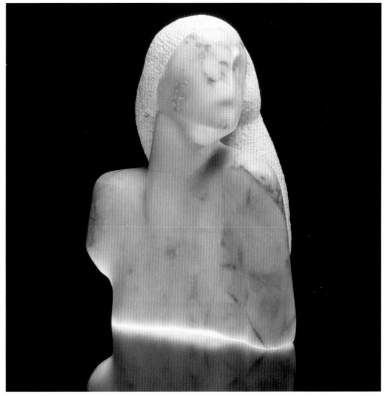

photo: Richard Faller

"joan"
alabaster
16" high
© 1979

David's studio at Eli Levin's

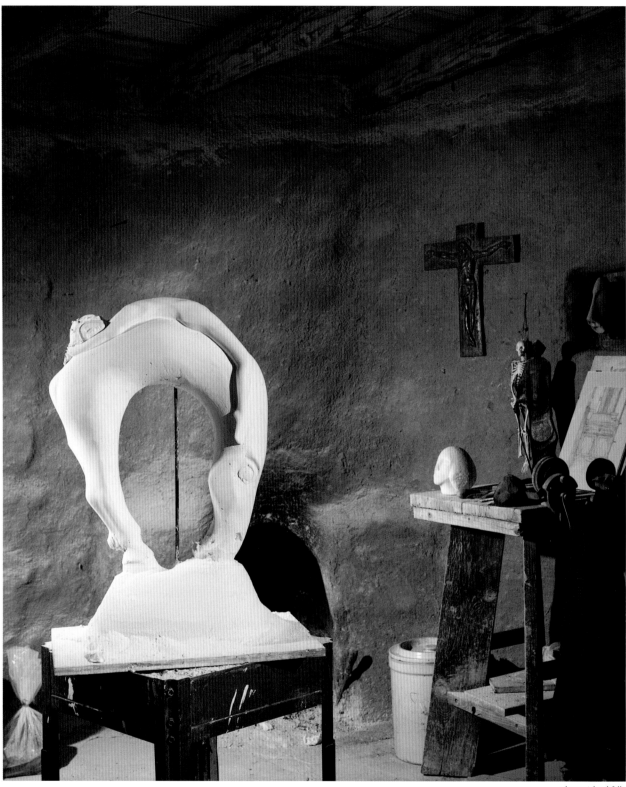

photo: richard faller

"dream ride"
plaster original
bronze
edition of 12

photo: richard faller

"caesura"
bronze
29" high
edition of 9
© 1992

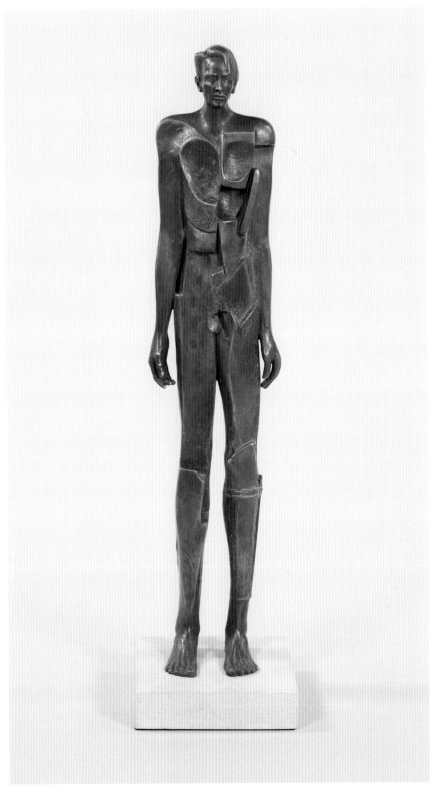

photo: richard faller

"contender"
bronze
35" high
edition of 15
© 1991

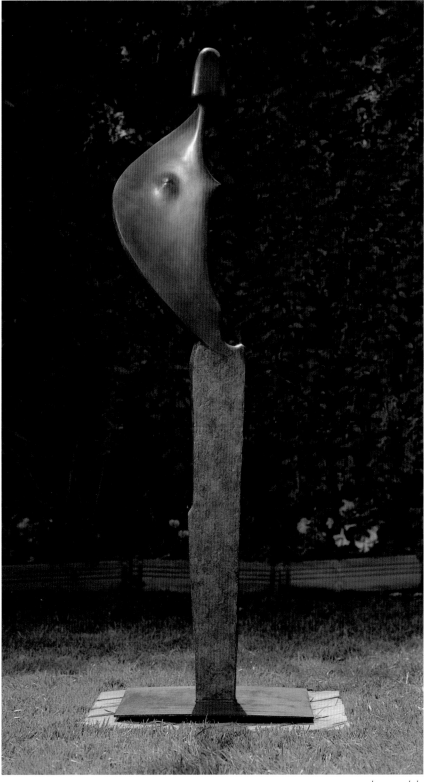

photo: peter kahn

"enigma"
bronze
60" high
edition of 7
© 1992

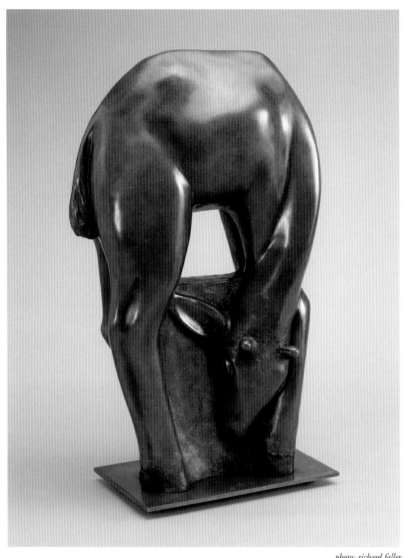

And always, there was art. Santa Fe, founded in 1609, is a tri-cultural community of Hispanics, Anglos, and Indians that's perched at 7,000 feet high in the Sangre de Cristo Mountains. It became an artists' colony in the early 1910s with the arrival of Sheldon Parsons, followed in the 1920s by Randall Davey, Fremont Ellis, John Sloan, Willard Nash, Will Shuster, and others. As Edna Robertson and Sarah Nestor observed of art's pervasive presence in Santa Fe in their book *Artists of the Canyons and Caminos*: "It is in the air itself, so clear and sharp in the high altitude that shapes and colors come through with startling intensity; brilliant primary colors of the daytime soften to pastels at twilight."

Pearson's best friend in high school, Chris Waldrum, was the son of legendary abstract

"antelope"
bronze
24" high
edition of 10
© 1987

expressionist painter Harold Joe Waldrum [1934-2003], known for depicting spiritual and mysterious aspects of churches with bold planes of paint, and a member of the burgeoning Shidoni Foundry and art cooperative in the Santa Fe suburb of Tesuque. Another high-school chum, Scott Hicks, was the son of Tommy Hicks, who helped found Shidoni in 1971, then became its owner. Hicks had been brought to Tesuque by a group called Arts Forum that wanted to develop a foundry for sculpture. As Hicks would later tell it, he bought five acres of land from Arts Forum, then he traded six sculptures for three more acres and a house. In 1973, at age 15, Pearson entered this creative milieu when he first visited Shidoni: "They invited me out to see a pour — a pouring of bronze. I was smitten." Now Pearson had a newfound purpose.

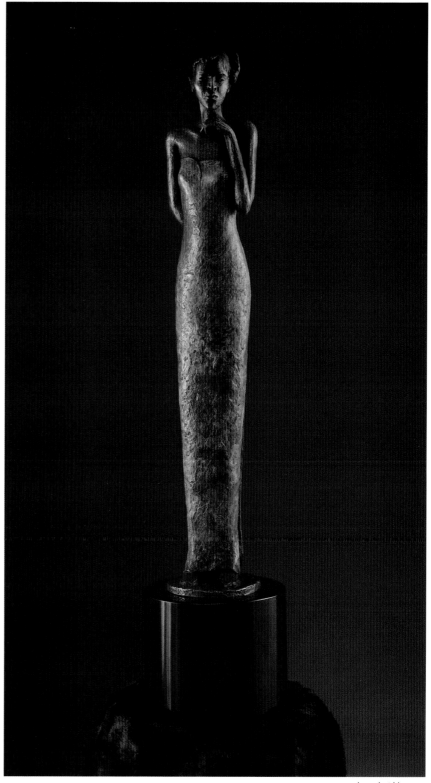

photo: david hoptman

"cochiti girl"
bronze
13" high
edition of 15
© 1994

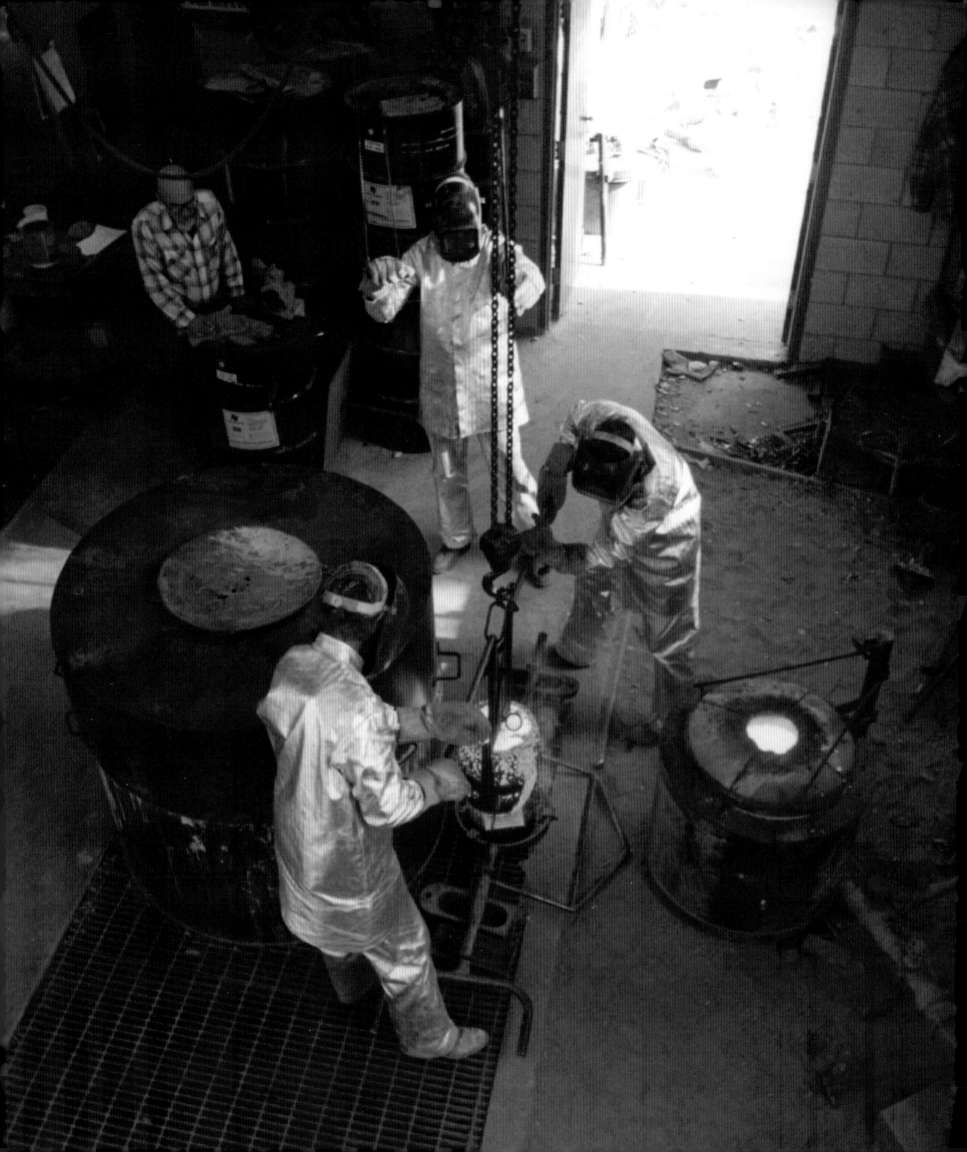

c h a p t e r 2 **the early years:
at shidoni**

It was 1974. "Chinatown" and "The Godfather Part II" were playing at movie theaters. On the radio, The Eagles were harmonizing on "The Best of My Love." David Pearson, 16, was having the summer of his life in Tesuque, New Mexico: along with his high-school buddy Scott Hicks, he'd been hired on at Shidoni Foundry by owner Tommy Hicks as an apprentice. Pearson's first assignment? Divesting, or cracking away the shell that covers each piece of newly cast bronze sculpture.

It was nothing glamorous — well, to be truthful, it was hard, dirty work. But Pearson marveled at the lustrous bronze shapes that emerged as he chipped away: "What was cool about it is, for me it was like carving — I would always

pretend I was a master stone carver making this artwork," he explains. "They would pour on Saturdays, and they would let the shells cool overnight. Then on Sunday, Scott and I would get out there and bust off the bronzes and get them ready for the chasers, who are the finishers, on Monday."

Pearson moved up into the job of metal chaser, or finisher, within a year. He learned about welding and patinas — the thin chemical coatings that can take a natural bronze into black and umber shades.

He was a natural at patina work. He mastered such processes as rubber wax molds, wax gating, and dressing wax. He loved

photos: nancy napier

working with bronze, later describing it as "old, magical energy with melting metal." For five years, he squeezed in hours whenever he could during the school year and spent all summer at Shidoni.

As a teenager working on the production of pieces by famed sculptors like Chiricahua Apache artist Allan Houser, Pearson set his own goals to match. "Allan was the king. He was the tops. He did the most work there, and I loved his work: the stoic quality of his faces, the diversity — from masks of faces to buffalo," recalls Pearson, who was responsible for the highly polished patina work on many of Houser's sculptures.

Foundry owner Tommy Hicks chuckles to remember Pearson back then: "He was just a skinny blond kid with a little smart mouth. He was willing to do anything to learn more about sculpture. He had a passion for it. When he has an idea, he takes it to the very end, as far as it will go. He doesn't jump all over the field. You can spot his sculpture and say, 'Hey, that's a Dave Pearson.'"

The self-taught Pearson learned every aspect of the sculpture process at the freewheeling foundry. Sculptor Doug Coffin, whom Pearson considers a mentor, dubbed him "New Wave Dave" while working with him, as a nod to his teenage know-how. "I knew him when he was a young whippersnapper," Coffin recollects. "I met him the first week I moved to New Mexico, when I was 26. He was young and full of energy.

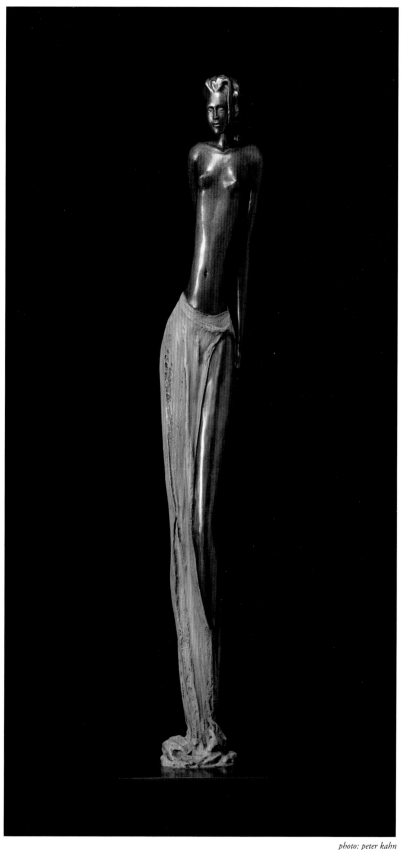

photo: peter kahn

"graced"
bronze
40" high
edition of 15
© 1998

Every Saturday, we would pour together. He's a sharp guy and he wanted to make it. He had ambitions."

As Pearson matured, so did Shidoni. When Pearson first went to work there, bronze pours took place in the old chicken coop that had been part of the previous business, Williams Egg Ranch. The new name, Shidoni, was a Navajo greeting. It was a freewheeling workplace — The Who

blaring on the sound system and an icebox stocked with beer, 25 cents a can. Pearson remembers, "You could drink beer from the moment you got there, but you couldn't drink scotch until 4 o'clock."

For Pearson, the Shidoni experience served as art school. Coffin, who'd already been to art school, points out, "Dave got to see guys like Dave McGary coming through there and

photo: courtesy shidoni foundry

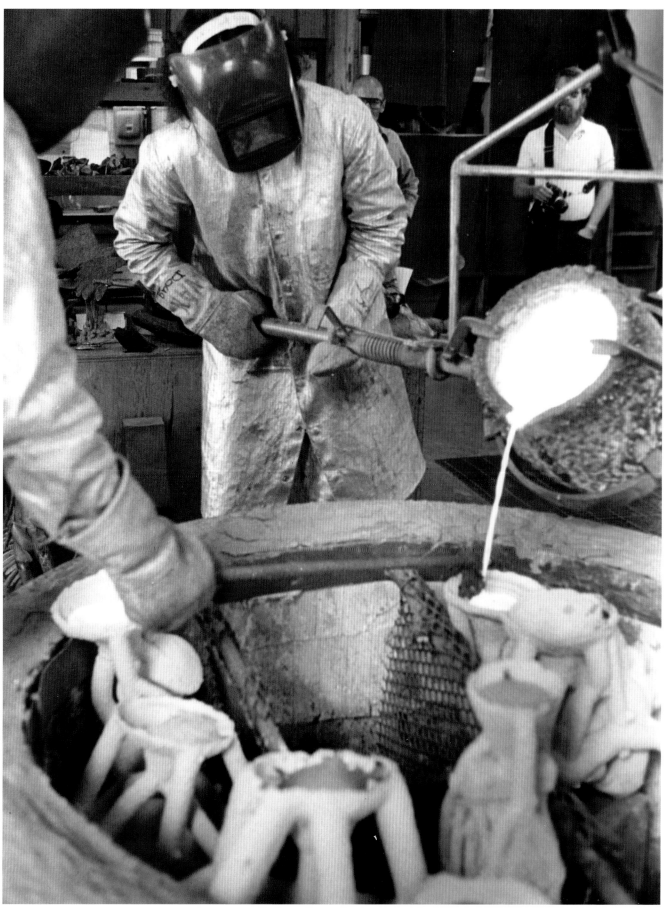

Doug Coffin
pouring bronze.

photo: courtesy shidoni foundry

so he got to see stuff firsthand that was better than any art school—what artists do, how they do it, how they sell it, and how to make a living with it. They don't teach you that in art school! He had hands-on knowledge of the real deal at an early age, and he acted accordingly, wanting to be successful in that chosen field."

Employees at Shidoni could avail themselves of the bronze-pouring process at reduced rates for their own art, a privilege Pearson eventually pursued, producing an elongated

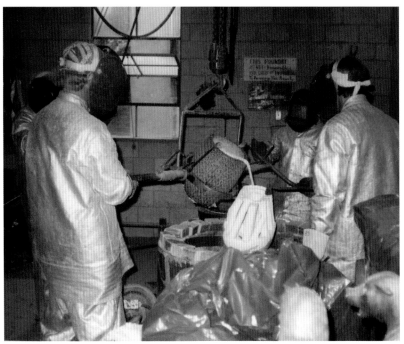

photo: courtesy shidoni foundry

female form that bespoke Egyptian and African art influences. He remembers, "I was 18. I made my first piece, "tracy" and put it in the gallery and it sold within the first week."

Coffin was impressed: "I remember the first bronze he did. It was this really long, tall, thin female form. And he's continued with that ever since. It was at a show there and he sold it. He's still on that same path, only with bigger, better, fabulous pieces. He's had

photo: dana tincher

"tracy"
bronze
35" high
edition of 15
© 1979

a singular vision as to what his art is about, and he's understood that's a good path to pursue. He keeps specializing in one thing — exploring the female form in a stylized, now signature, look. He's kept experimenting and refining and understanding and developing."

Pearson's bronzes began selling steadily, drawing interest from galleries in New Mexico, Colorado, and California. In 1979, at age 21, Pearson left Shidoni. "You can do anything you want," he'd decided, having observed such feats as Coffin's creation of a 30-foot-tall totem piece in two weeks.

The respect runs both ways. Coffin acknowledges, "Dave's the kind of guy that nobody gave it to him. He's been completely self taught. He knew what he wanted to do, and what he thought he could be good at."

At Shidoni, everyone liked him, he did what he was supposed to in the right way, and Shidoni launched him. He's been on

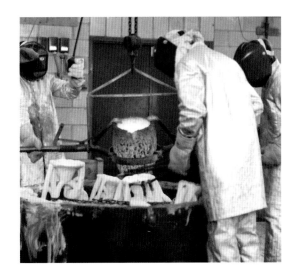
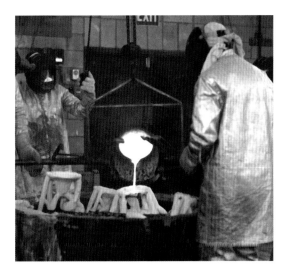

photos: courtesy shidoni foundry

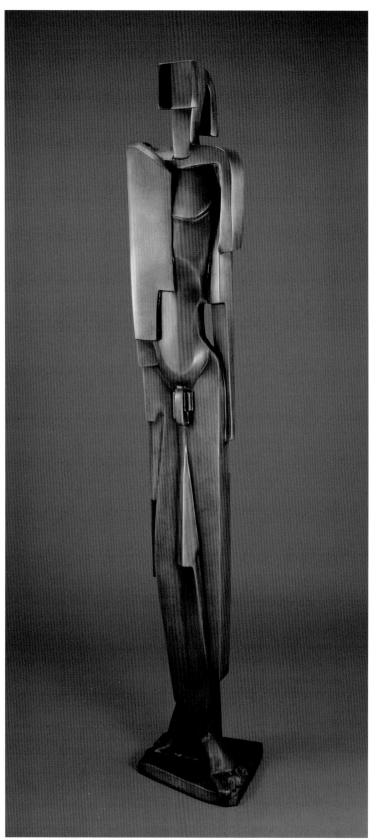

photo: richard faller

"ragman"
bronze
60" high
#1/1
© 1988

his own since he was 16. He's made it 100 percent on his own terms, his own effort. Nobody's ever opened any doors for him, other than himself."

Today, Shidoni Foundry is the oldest foundry in the Southwest under the same ownership and boasts a sprawling sculpture garden; among the 75 acclaimed artists of its past and present are Allan Houser, Dave McGary, Bob Haozous, Veryl Goodnight, Frank Morbillo, Michael Naranjo, Doug Coffin, and David Pearson. Tommy Hicks still owns Shidoni, Scott Hicks is its president—and Shidoni casts Pearson's larger sculptures. Tommy Hicks reflects, "Dave's not afraid to pay his dues. An artist has to pay their dues — they don't just start out good and that's it. They have to go up and down. When the breaks go against them, it makes them stop and think about what they really want to do. He's had breaks go against him. He's stuck with it."

The eighties were going to challenge Pearson—and he was going to realize that a career as an artist wasn't always as carefree and communal as it seemed during those early years at Shidoni.

c h a p t e r 3 **the foundry years:
pushing the
boundaries**

*L*eaving the Shidoni colony behind was a difficult passage for Pearson. He gravitated to another artistic community—a rental at artist Eli Levin's historic compound on Don Miguel, off Upper Canyon Road. Canyon Road is Santa Fe's famed art district, where Los Cinco Pintores, including Will Shuster and Fremont Ellis, hand-built their own adobes while establishing Santa Fe as an art colony back in the 1920s when it was only a town of 7,000.

Now it was Santa Fe's go-go eighties. "Santa Fe style" was a national commodity—a romance novel, natural soda, pale ale, and cookie were all named after Santa Fe. Pickups cruised through town loaded with firewood and art; celebrities like Gene Hackman and Val Kilmer moved in. A prominent New York publication dubbed Santa Fe "the most 'in' place in the United States," and Harlequin Books tagged it "the most romantic city" in America. It had taken almost four centuries

David giving a mold making demonstration at the Institute of American Indian Arts, Santa Fe, New Mexico.

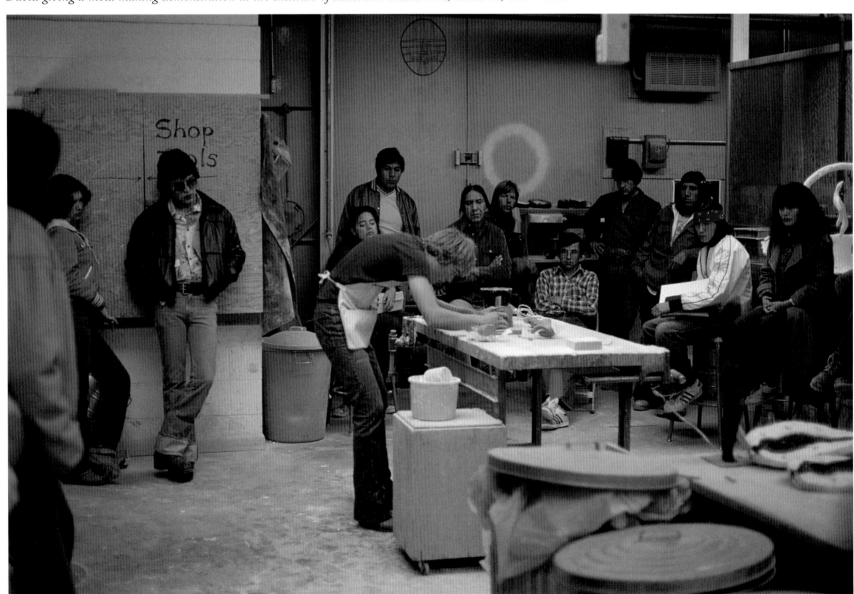

photo: doug coffin

for Santa Fe to attract 50,000 residents, but the population boomed from 53,000 in 1980 to 66,100 at decade's end. The economy didn't necessarily keep pace: one of three locals was subsisting on the federal minimum wage of just $3.35 an hour. These were heady times, and as Pearson aged through his 20s, marrying and starting a family of his own, there was one voice of experience he came to particularly value.

Eli Levin, a Santa Fe painter of bar/dance hall scenes—who would later change his name to Jo Basiste in the 1990s—became Pearson's landlord, mentor, and de facto professor of art history. Pearson explains, "He's very academic. He just knows everything about art. He lives and breathes art. He's one of the most educated persons I've ever known. We would sit around at night with other artists—of course, they were all his friends—and talk about art until two o'clock in the morning. We would talk about Matisse, Modigliani, about artists' lives." Often joining them would be mod landscape artist David Barbero [1938-1999] and desert landscapist Arthur Earl Haddock [1895-1980], along with Bruce Cody, who painted architectural scenes.

"David was like a younger brother to me," recalls Basiste, now 66. "I'm a painter, but during the time he was here, I actually stopped painting and sculpted. We spent many hours in the yard carving. I carved wood, and he carved both wood and stone. He had quite an influence on me. And we worked on the house together—there was always some plastering and rebuilding. He was like a shot of adrenalin."

This was an artists' enclave—so emblematic of Santa Fe that a

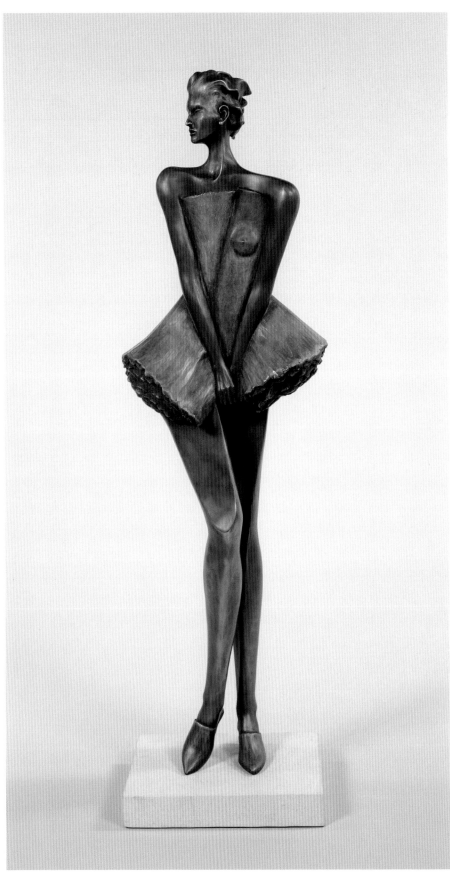

photo: richard faller

"la fête"
bronze
42" high
edition of 9
© 1991

scene for the 1970 movie "Red Sky at Morning" had been filmed on the street—and so when he replastered, Pearson embedded three of his sculptures into the new walls: he set a carved head in two fireplaces, and another in an outside wall. "David was idealistic and making these endless stone and wood carvings was a labor of love. He definitely had determination," Basiste says. "I would say his forte is elegance. His work over the years has gotten more consistent and elegant. He always had a feeling for the material and a nice simplicity."

Even though Pearson's sculptures were being sold at galleries in New Mexico, Texas, Colorado, and Arizona, it was a uneven living, so in 1982 he accepted a position at Dwight Hackett's Art Foundry in Santa Fe, eventually becoming its director and master sculptor. He helped Hackett to revamp operations, adding more metal workers and moving to a larger location on All Trades Road. As Art Foundry's reputation grew, Pearson found himself casting the work of leading blue-chip contemporary sculptors from both the East Coast and West Coast — art stars like Bruce Nauman, Terry Allen, Ron Cooper, Bill Barrett, Fritz Scholder, Luis Jimenez, David Salle, Tom Otterness, and Kiki Smith.

"We were at the top of the game," declares Pearson, who appreciated his new colleagues' bolder, more conceptual slant. "One of the nicest things about being around successful artists, especially those type of artists, is that it's not really like the process is so picky. The piece is what's important—not the chasing of it or the waxing. At other foundries, the artists could be really picky—you're carving out little ears on wolves and making feathers. Here they were thinking way bigger.

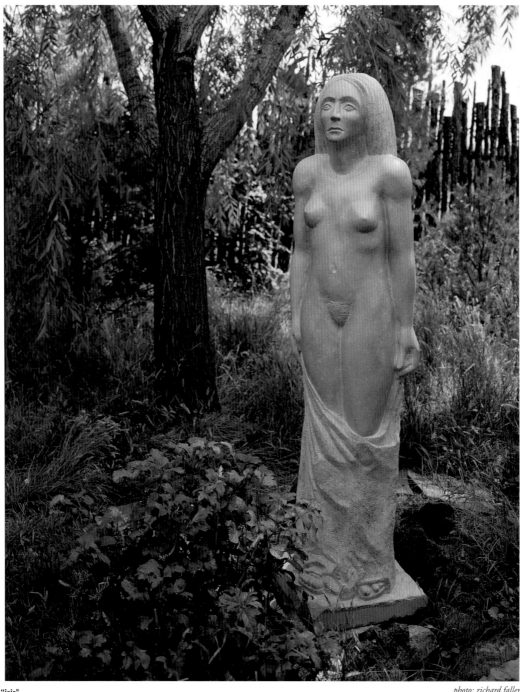

"isis"
indiana limestone
60" high
© 1985

photo: richard faller

Whatever happened in the casting of the work, is what happened. You know, if there was a wax drip or there was a shrinkage, then that was part of the piece." He learned to push the boundaries of forging—"We were casting tumbleweeds and using tinfoil for textures, burning out loaves of bread and casting them." A single casting for a Bruce Nauman museum piece included five life-sized elk with

four life-sized deer and two life-sized bobcats—"Bruce comes in and everything is cool and no problem with money and no problem with time," Pearson remembers.

Among Pearson's most meaningful collaborations were those

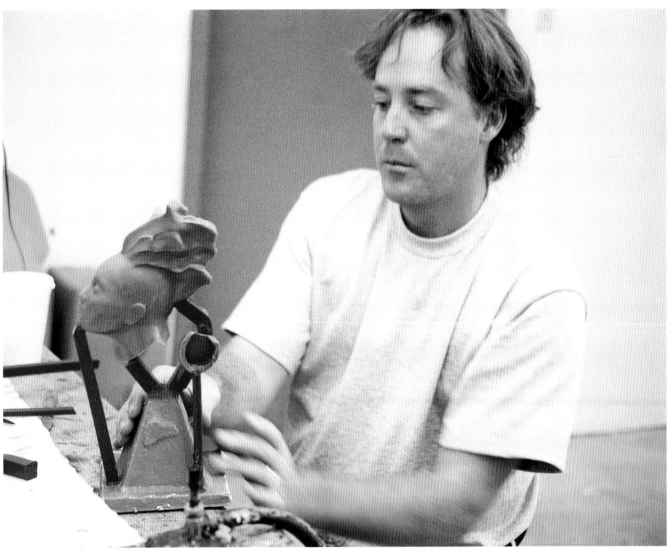

with sculptor/painter/ musician/songwriter Terry Allen, the Texas multimedia artist who emerged from the Austin scene to settle in Santa Fe. Allen, who's recorded with Lucinda Williams and David Byrne, has created sculptural installations for such high-profile sites as Houston's George Bush Intercontinental Airport and San Francisco's Moscone Convention Center. "I was always under the gun and always had to get something done, and usually did it," Allen, now 61, recalls of the Art Foundry days. "David worked with me on the first bronze I ever did. He helped me a lot with working with clay and with armatures and how to build things." When Allen needed him, Pearson was always there— "David's the kind of guy who will work with you till it's done. He cares about what he does. He works alongside you, and he gives himself to the limit whatever the project is," says

Allen, adding, "David's certainly an easy person to work with. He's got a good sense of humor. And he likes dogs as much as I do." Pearson helped set the mood at Art Foundry. "The whole environment was about making work. It wasn't about just dicking around. It was about making work and everyone there was serious about working," recollects Allen. "The foundry helped you with the processes—like welding and pouring. David had a huge sort of book of ideas to work from. Most of them were technically based and also he's very diligent and a hard worker. I respected that and admired that and needed that."

After a significant 10-year run at Art Foundry, Pearson left to head a 700-piece casting project for Notre Dame's College Football Hall of Fame. Then in 1995, one year after Allan Houser's passing, he was hired to design and build a bronze foundry at Allan Houser Inc. for production of all remaining editions of Houser's work to be cast in bronze, and to be patina master and mold restorer for all remaining editions. The foundry, along with the Allan Houser Gallery and sculpture garden, stands on the family's 100-acre compound south of Santa Fe.

The Houser project took Pearson three years—and turned his thoughts to mortality as he approached 40. "Look at Allan," Pearson urges. "He was at the top of his game. That's what life is all about. If you just reach your own top, your own peak." Pearson knew what he had to do next.

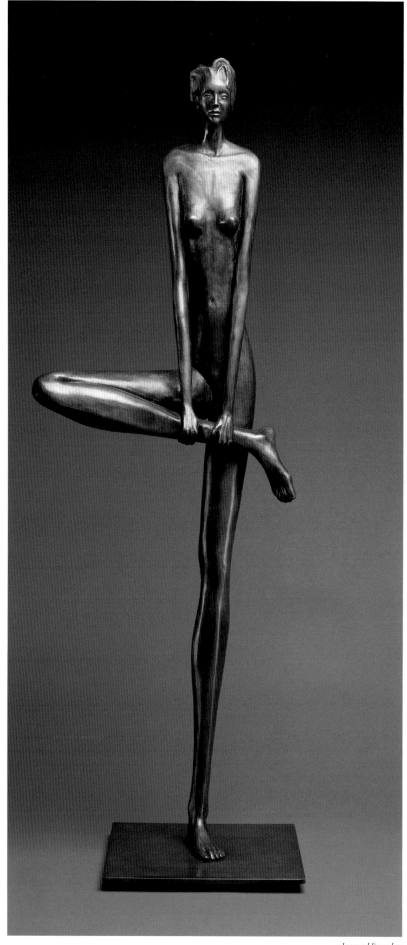

"morning sun"
bronze
40" high
edition of 15
© 2004

c h a p t e r 4 **the studio years
1997 - present**

photo: addison doty

*D*riving south of Santa Fe into the Galisteo Basin on Highway 14, the horizon opens up. Fields of grass stretch into a cornflower blue sky in an almost Midwestern tableau. Cottonwoods rustle; junipers and pinon pines stand quietly. Horses wander nonchalantly in pastures, and dogs are friendly presences on ranches situated along dirt lanes that didn't even have names in the 1990s. That's when Pearson bought 20 acres of land here in the San Marcos/Lone Butte area, a high llano or plateau that was centuries ago a center for farming and pottery-making in the upper Rio Grande area, but was abandoned after the 1680 Pueblo Revolt. Today it's mostly private homes, although if you survey the open range in the direction of the Sangre de Cristo Mountains, you may sight a stray antelope. And if you drive near David Pearson's ranch, you may hear the blues-rock strains of Stevie Ray Vaughan.

Pearson first got familiar with the area while working with Allan Houser, who lived just two miles away ("I would see him sitting on his porch just in this total calmness and I thought, someday I'm going to live like this," he says), and then building the foundry at the Houser compound brought him back to the area. By this time he was married to his second wife, gallery owner Patricia Carlisle, who had just launched her own art gallery, Patricia Carlisle Fine Art, representing his sculptures among other art. "We saw this place, and we knew it was perfect. I could spend the rest of my life here," Pearson remembers.

They bought the land in the mid-1990s and began building a studio for Pearson on it—a house would follow. "I was still working in the foundry at Houser's and I somehow knew it

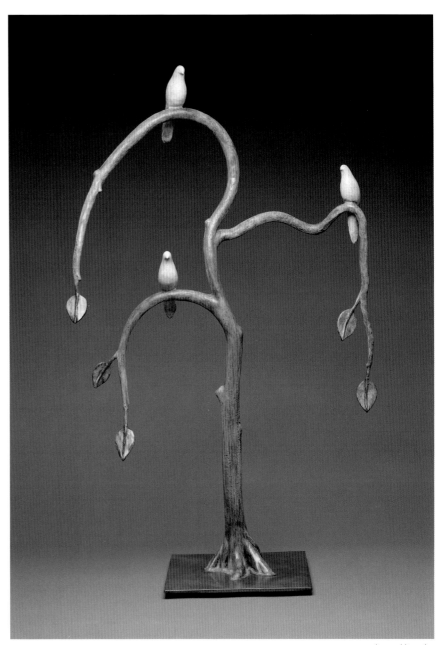

"harmony"
bronze
40" high
edition of 15
© 2003

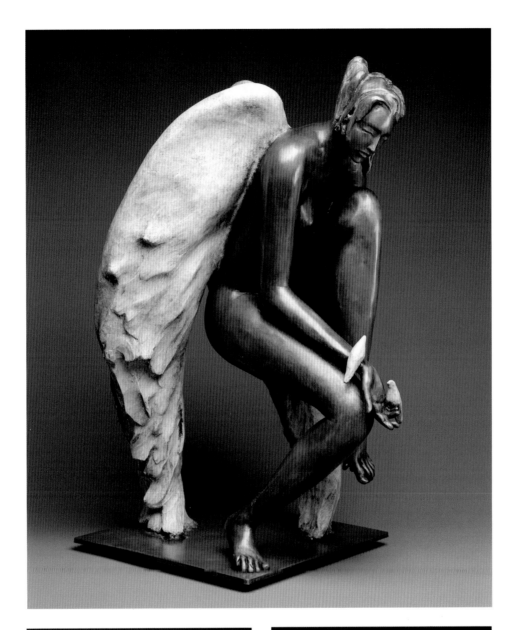

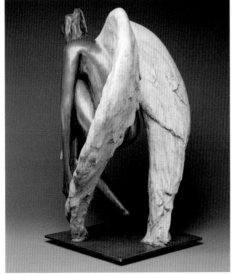

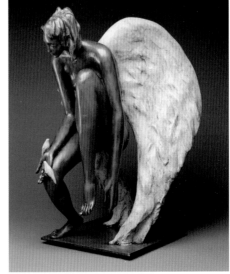

"the blessing"
bronze
24" x 16" x 24"
edition of 15
© 2003

photos: addison doty

was time to fulfill the dream of being on my own. So I went out to my car and I got on my cell phone and called Patty and I said, 'I'm going to quit this job. I'm going to go full time into sculpting.' And she said, 'I think it's time too.'"

Pearson thought a lot about Houser as he constructed his own studio just over the hill from Houser's: "Allan was the king, the man. He never faltered. He was a workhorse. He was a mule as far as artists go. He would work from sun up to sun down. I mean, he was always hitting it strong. And that's what I do. I hit it. I work. And I love what I do."

His first studio here, finished in 1997, was a single room. Hot wax operations were along one wall, metal and patina areas in other parts of the open-ceilinged shop. But it was all his, and he could work from dawn to dusk on his own ethereal sculptures—lithe, elegant figurative pieces, sometimes with cubist elements. They flowed out of him. Bronze figures inspired by tales from Greek mythology, like that of rebellious Clytie—who angered the gods, so they transformed her into a sunflower. Narrow, elongated figures, sometimes wrapped in gauze to create a mummy effect. Arts writer Michael Koster wrote of them, "Stoic faces from another time evoke the stillness of the tomb, the dignity of an age long past."

In *The Santa Fe New Mexican*, Pearson explained, "I think of my work as being very strong in line, as being peaceful with a sense of presence to them. The style can express anything,

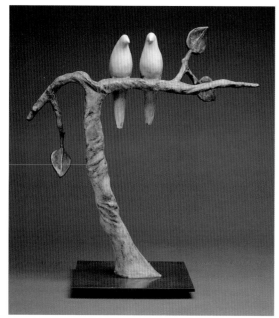

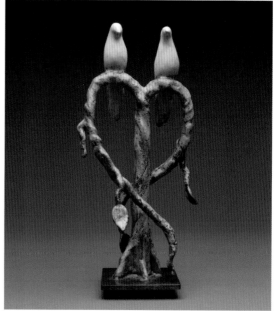

photos: addison doty

"bonsai"
bronze
18" high
edition of 15
© 2002

"seven angels"
bronze
10" high
edition of 15
© 2004

"wing & prayer"
bronze
13" high
edition of 15
© 2005

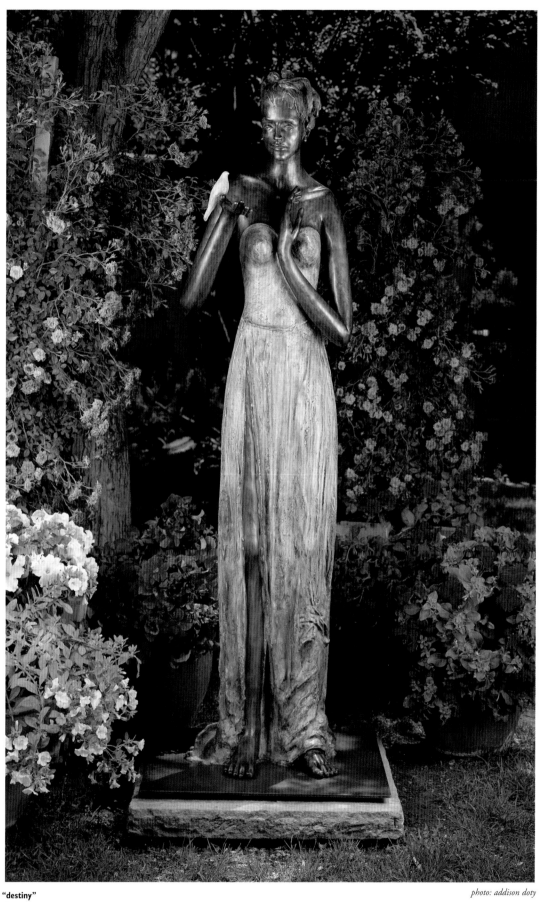

"destiny"
bronze
5' 8" high
edition of 12
© 2004

from a person walking to someone just being lonely." He expounded, "It's a combination of form, feeling, and abstraction that reaches for an aesthetic beauty, rather than conveying a more complex expression."

He experimented with male forms, androgynous figures, and one-winged angels, but he kept returning to long, slender female forms, portrayed in sleek contours and elongated designs. He elaborated in Focus Santa Fe in 1999, "Elongation comes to me quite spontaneously, and it has always been an integral part of my vision. The Etruscans believed that shadows were elongated figures representing the soul, and shadows were believed to contain the spirit of a person."

Pearson's signature style was refining itself now: linear, tapered figures that are idealized rather than individualized. Sometimes they are more abstracted, sometimes more representational, but always there is a feeling of universality, of belonging to every culture, every era. They evoke the natural world at times, and at others, the spirit world. There is a strong sense of presence and a hint of romanticism. The pieces seem to command their own space, creating a kind of zone between the sculpture and observer. This allows the observer to step into a different realm in which the sculpture resides, experiencing its presence in its own space.

Pearson reflects of his work, "Everything has a progress. The mummies were first. Then the angels were second. And then the birds came into the picture. I've always done the females.

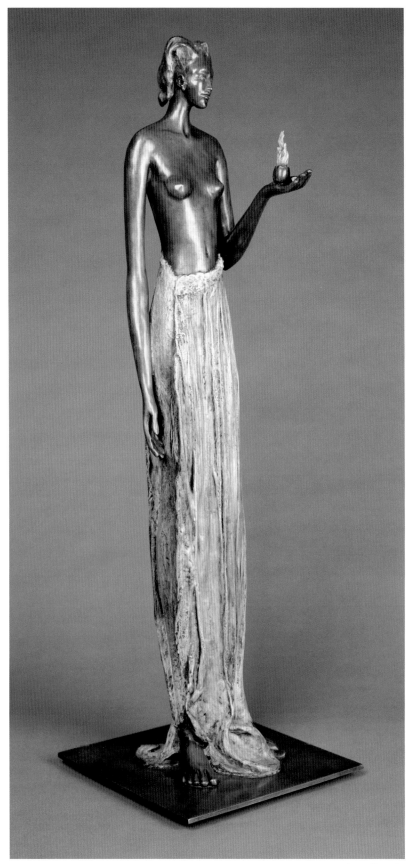

photo: addison doty

"the gift"
bronze
41" high
edition of 15
© 2002

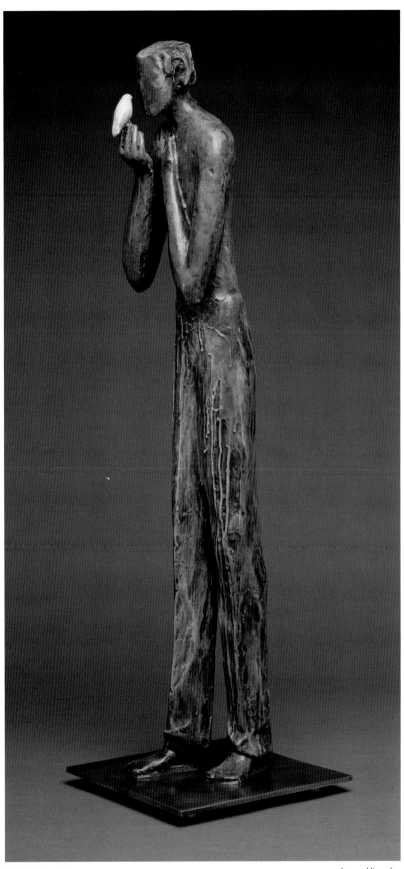

"lessons of a songbird"
bronze
31" high
edition of 15
© 2001

That's just what I have a feeling for. The males that I've done, which are very few, tend to be torn up and ragged, stiff and stark, beat up. Whereas the women are totally free flowing—it's receptive energy." He never uses models, and rarely photographs. "A lot of times these pieces come through me, and when they are finished I can't believe I made them. It's just a strange thing—it's like the feeling is there when you're making the piece, and you just do it."

Now Pearson's oeuvre began commanding increased attention. *New Mexico Magazine* commended his sculptures of "people of light, spirits who have evolved out of the material plane and now guide and protect the rest of us." Jon Carver memorably reflected in *THE Magazine* in 2000, "His bronzes recall the ancient Egyptian figurines that were placed in the pyramids as guardians for the dead as they made the journey from this world to the next. Often acting as a repository for the ka, or soul, of the departed, these forms were simplified, slightly stylized, and often exhibited an otherworldly elegance." Carver surmised, "Cycladic idols also come to mind. These had a tremendous influence on the Italian sculptor-turned-painter Modigliani, and account for the elongation of form that is a hallmark of his work. Pearson, like Modigliani and the great 20th-century sculptor Giacometti, stretches his figures in a similar manner. The collusion of length and elegance is a long-standing aesthetic, striding from the paintings of the Italian Mannerists of the 1500s onto today's runways of high fashion."

As the accolades poured in, Pearson hunkered down at his country studio, traveling further into a world of spirit, emotion, and humanism. The qualities of harmony and balance that had attended his autumnal equinox birth now seemed to grow stronger as, in his 40s, he delved into deeper realms.

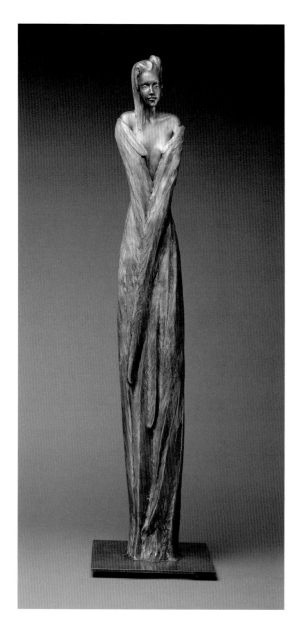

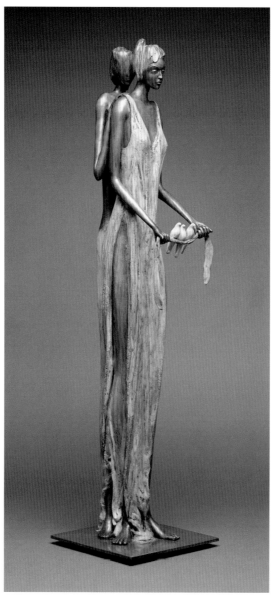

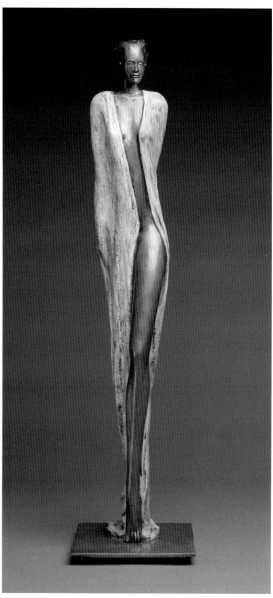

photos: addison doty

"dawn"
bronze
41" high
edition of 15
© 2001

"grace"
bronze
40" high
edition of 15
© 2004

"dreamstate"
bronze
29" high
edition of 15
© 2000

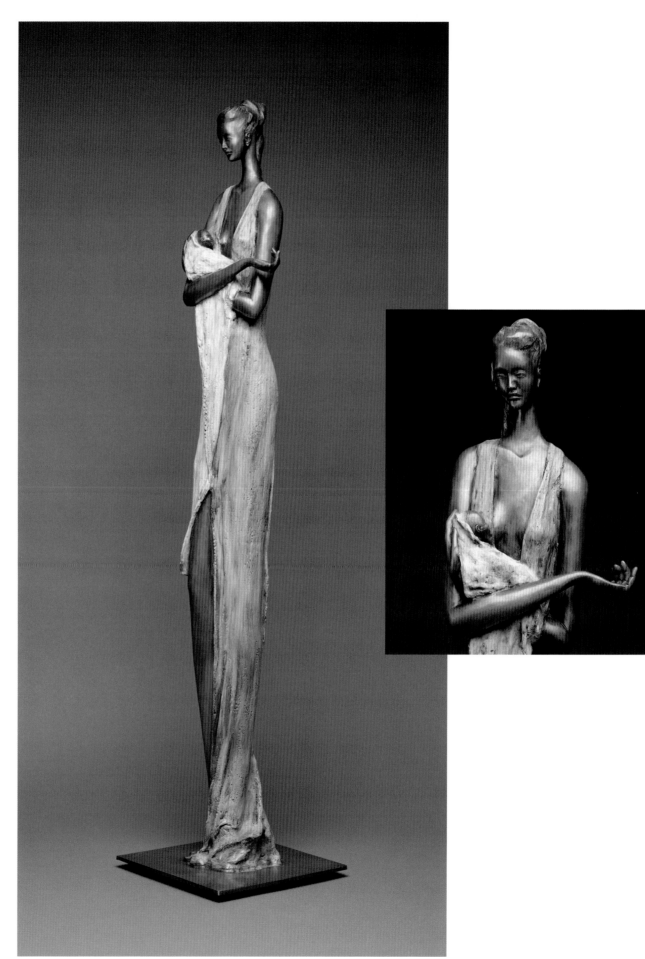

"first day"
bronze
45" high
edition of 15
© 2003

photos: addison doty

chapter 5 **art in public spaces:
recent highlights of
david's career**

photo: addison doty

"angelic being (large)"
bronze
5' 8" high
edition of 15
© 1998

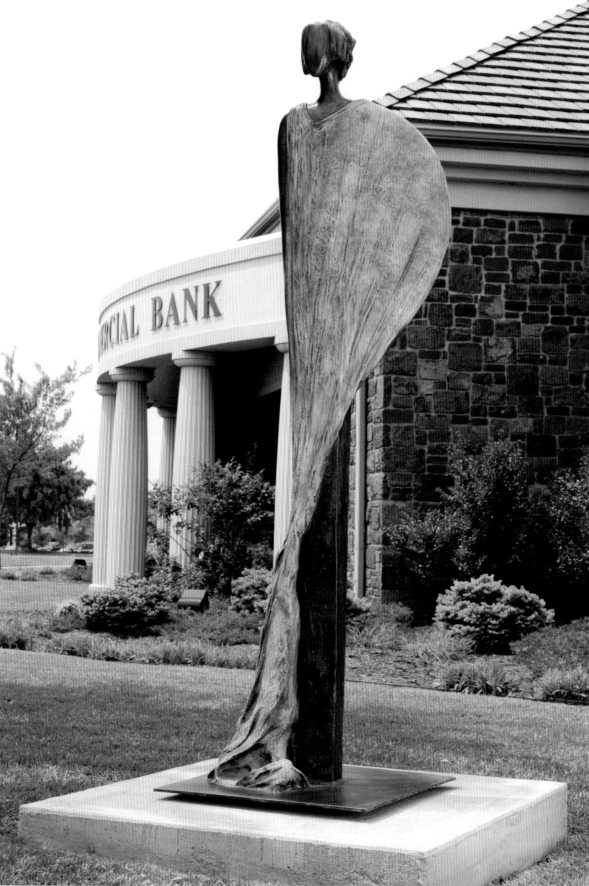

Collection First Commercial Bank and City of Edmond, OK

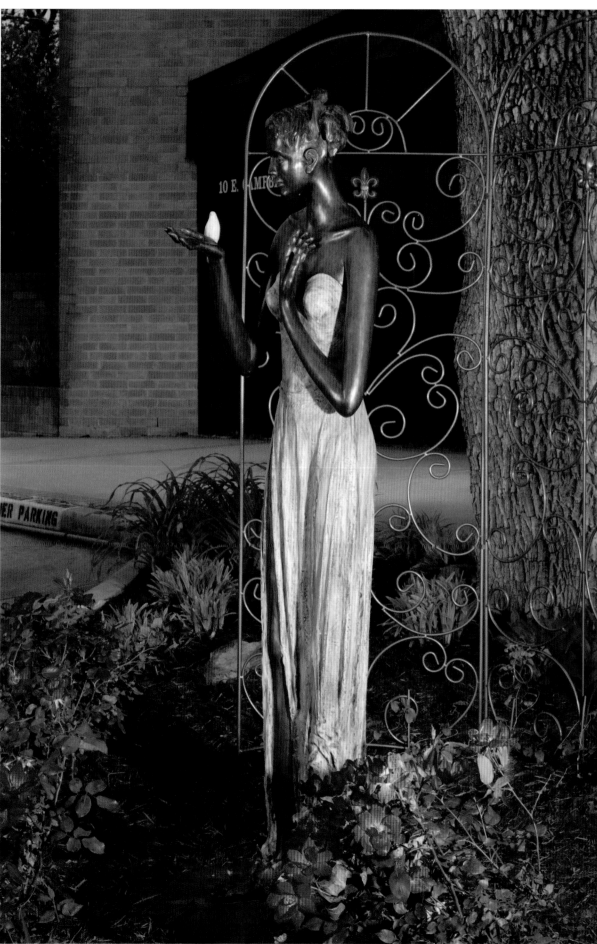

Collection Mo and Richard Anderson, Betty and Pete Reeser at Keller Williams Real Estate

photo: addison doty

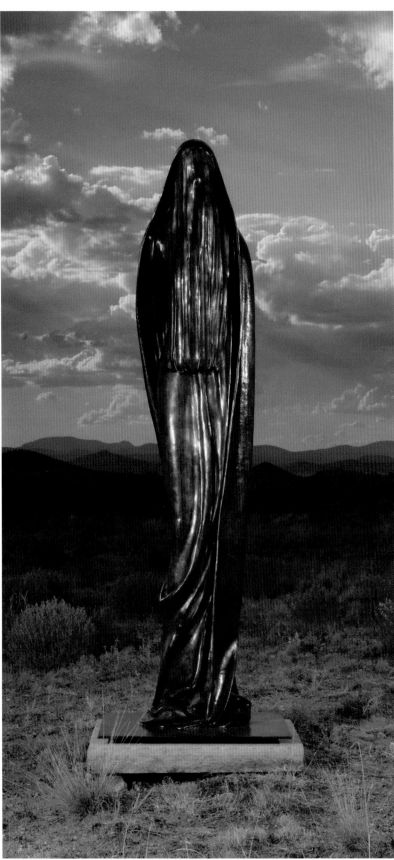

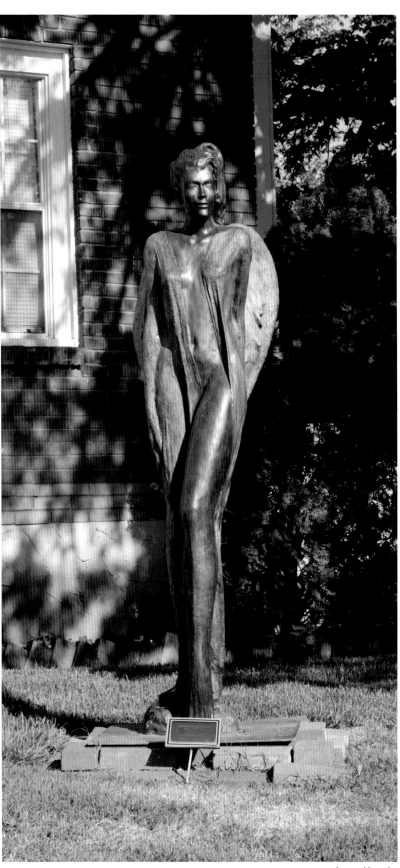

Sculpures this page collection of Randel Shadid and Stephen Schaus, City of Edmond, OK.

photos: addison doty

"silent desert"
bronze
5' 2" high
edition of 12
© 2004

"morning mist"
bronze
5' 11" high
edition of 9
© 2000

"love doves"
bronze
13" high
edition of 15
© 2001

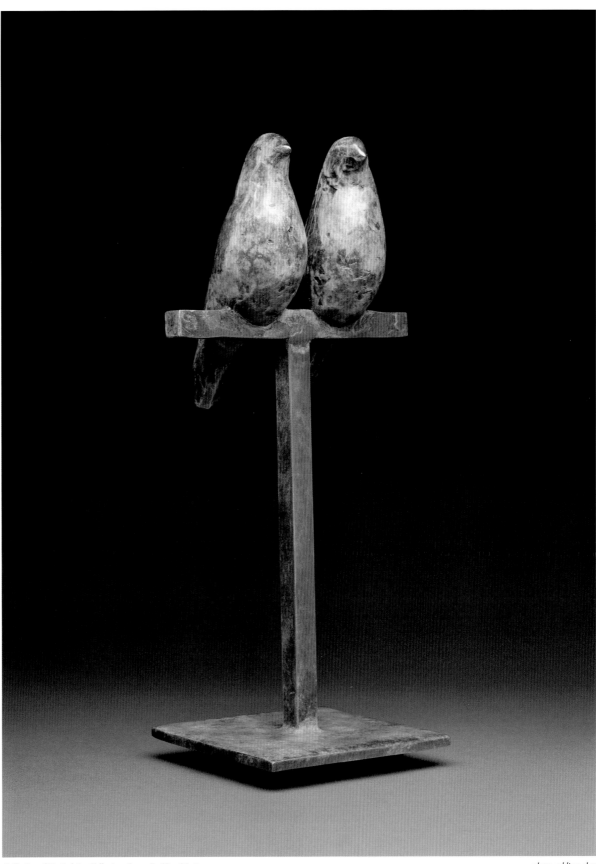

Collection of Capital Art Collection, Santa Fe, New Mexico.

photo: addison doty

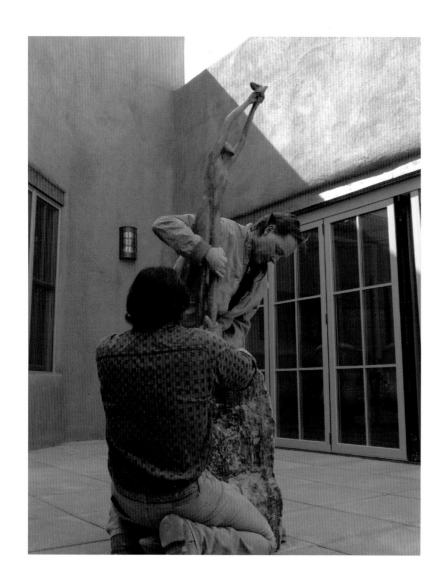

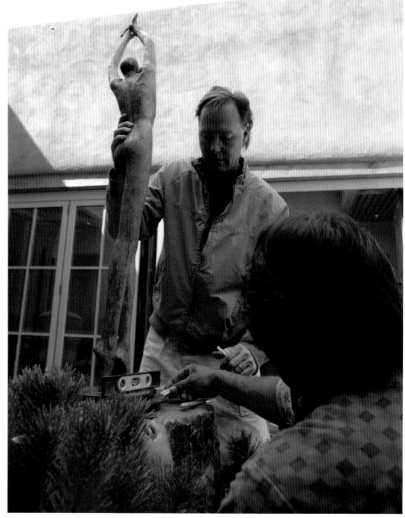

photos: addison doty

Installation of "Transcend" at
Los Alamos National Bank
Santa Fe, New Mexico

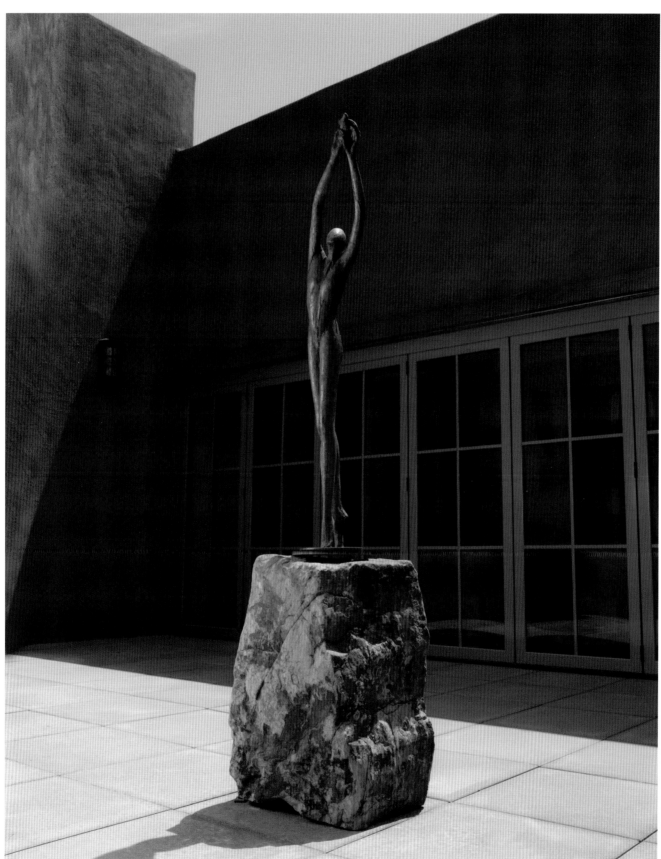

"transcend"
bronze
52" high
edition of 12
© 2001

photo: addison doty

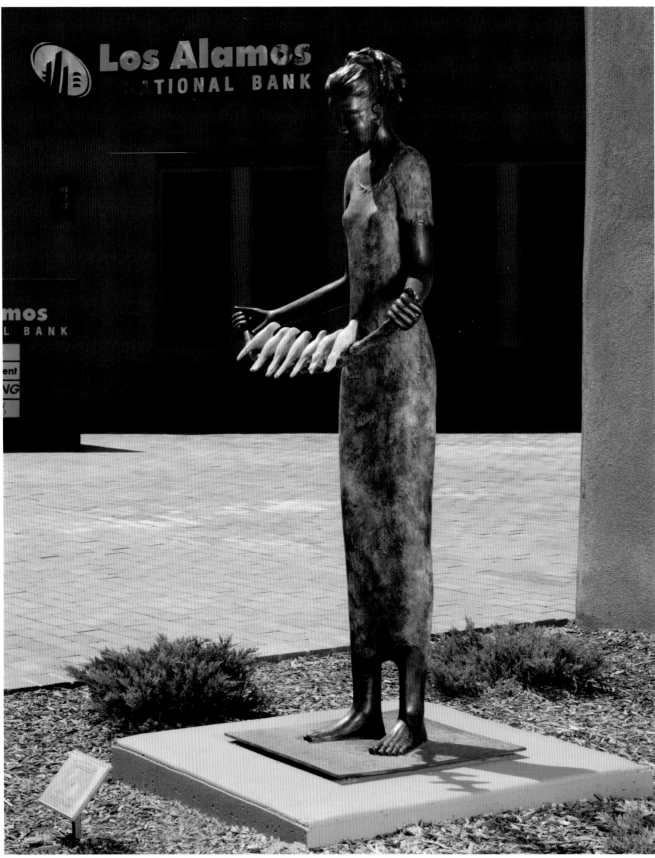

Collection Los Alamos National Bank, Santa Fe, New Mexico • Collection Edmond, Oklahoma at Broadway and 1st Street *photo: addison doty*

"innocence"
bronze
5' 2" high
edition of 12
© 2001

*R*ecent Milestones

September	2005	Public Art Purchase by City Of Edmond, Oklahoma "Silent Desert"
August	2005	Honorable Mention, *Sculptural Pursuit Magazine* "Songs for the Soul"
September	2004	Public Art Purchase by Los Alamos National Bank, Santa Fe, New Mexico "Transcend"
August	2004	Public Art Purchase by Los Alamos National Bank, Santa Fe, New Mexico "Innocence"
June	2004	Public Art Purchase by City Of Edmond, Oklahoma "Destiny"
May	2004	Public Art Purchase by Gastonia Memorial Hospital, North Carolina "Finch"
February	2004	Public Art Purchase by First Commercial Bank, Oklahoma "Angelic Being"
August	2003	Honorable Mention, Museum of the Southwest, Texas "Nightingale"
December	2002	White House Artist for Christmas Tree, Washington, D.C. "Unique Bronze Bird"
May	2002	Award Winner, National Competition Gateway Museum, New Mexico "Swan Song"
April	2002	Public Art Purchase by City of Edmond, Oklahoma "Innocence"
April	2002	Public Art Purchase by City of Edmond/Shadid, Oklahoma "Morning Mist"

David and Patty
with Laura Bush
for presentation of
"Unique Bronze Bird"
ornament.

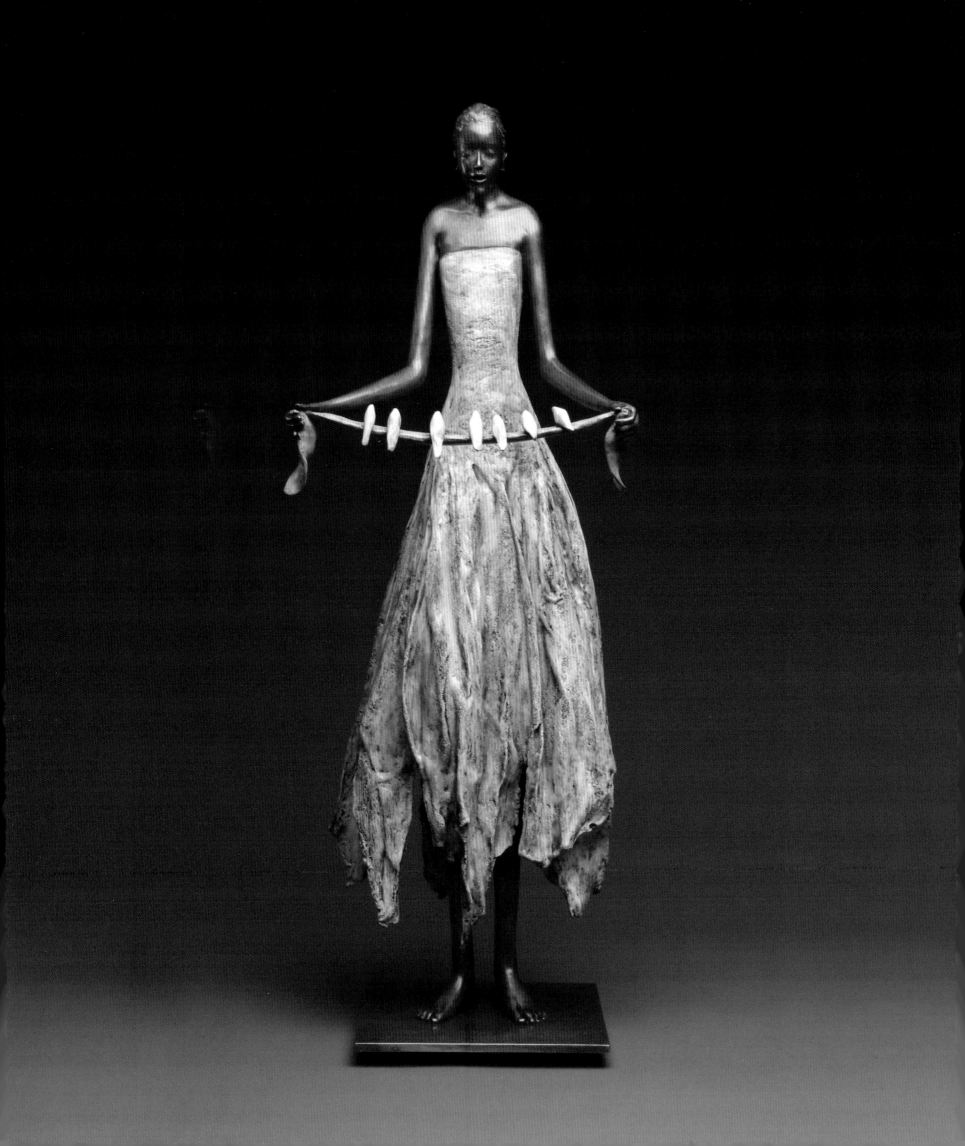

"songs for the soul"
bronze
29" high
edition of 15
© 2004

photos: addison doty

HOW DAVID PEARSON CREATES A BRONZE SCULPTURE

David Pearson begins creating his original sculpture, usually in Chavant oil clay. He takes his inspiration from ancient civilizations, the human figure, nature and the birds around him. Once the original sculpture is complete it is ready for the bronze casting process.

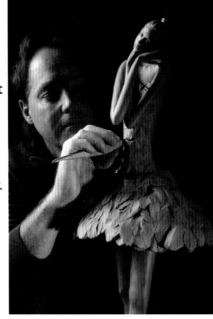

To give a little background, David's studio is out on 20 acres south of Santa Fe. Here he has several different rooms, a sculpting room, a wax room, a chasing room, and a patina room making up his own personal foundry. The only processes he doesn't do at his studio are the gating/dipping/pouring processes. The lost wax process David uses dates back centuries and is the traditional casting method used by foundries all over the world today.

Following are the seven steps David uses to cast his work.

THE FIRST STEP—MAKING THE MOLD

Making the mold begins with silicone rubber meticulously painted directly on to the clay original. This is to ensure that the exact surface of clay is picked up in minute detail. This rubber coating is built up four layers thick. Then a plaster mold is made over the rubber in three or four layers until it is approximately one inch thick. Once dry, the mold is cut in half, creating two sections. On complicated molds there may be three or four sections. This completed mold now becomes David's "mother mold" that will be used to create each piece in the edition. The clay original is destroyed.

THE SECOND STEP—THE CREATION OF THE WAX

The wax is the second positive of David's original. David paints a special layer of wax heated to 215 degrees to once again pick up all the detail of the original and ensure there are no bubbles.

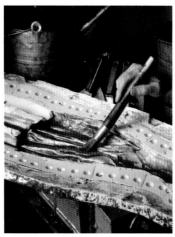

Once both halves are ready, he closes up the mold and slushes the mold using a completely different hot wax at 190 degrees. As the wax cools over the next several minutes it will build up to a thickness of 3/16". At this point the mold is turned upside down and the excess wax is poured back in the large pot. Many hours later after the wax has hardened, he very carefully pulls the two halves of the mold apart and removes the wax.

The mother mold is now put into storage to await the next wax. David pulls each wax as that particular sculpture sells. This ensures the highest quality of each piece in every one of his editions. Now he begins the long and extremely detailed dressing of the wax. He takes out all the seam lines from the mold and

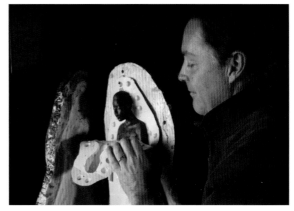

painstakingly goes over every face, ear, hand and foot to ensure that the wax reproduction is as close to the original as possible.

After David has finished the dressing, he then takes the wax to the foundry.

THE THIRD STEP—PREPARING FOR CASTING "GATING" and "THE DIP"

The wax is prepared for the ceramic shell. It is gated using wax rods attached to the wax sculpture. A pouring cup or funnel to accept the molten bronze is attached to provide a path for the hot liquid metal.

Now the wax is ready for the dip. Dipping the wax with all of its gates into

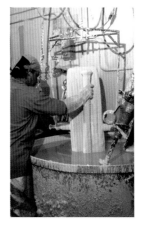

a liquid ceramic solution is the second mold in the process. This is a layering effect involving dipping and coating with sand approximately 7 to 12 times depending on the size of the sculpture. Each layer must dry thoroughly before the next dip. The ceramic shell is incredibly strong in order to hold the weight of the hot liquid bronze during the pour.

THE FOURTH STEP—THE BURNOUT
Once the shell has dried with its final coating, it is then put into an oven. At 1200 degrees the wax melts out—thus the term "lost wax". The ceramic shell is now hollow and ready for the pour.

THE FIFTH STEP—THE POUR
After the ceramic mold has been inspected for cracks and repaired from the burnout procedure, the mold is pre-heated in the same oven to 1900 degrees. This firing takes the ceramic shell to its highest level of strength in order to accept the molten bronze at 2000 degrees. After the bronze is poured and cooled, the ceramic mold is broken and the bronze is removed.

THE SIXTH STEP—CHASING THE METAL
The majority of David's work is cast in several sections. So now the refining begins. He removes all of the gates used during the pouring process. Plugs are welded back in place. The different sections are welded back together and the re-surfacing of all textured and smooth areas takes place. This is time consuming and physically demanding work!

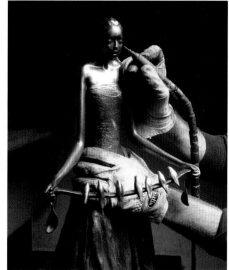

THE SEVENTH AND FINAL STEP—THE PATINA
This is the final stage—the art of color. It is one of the most important stages in the completion of any bronze. Using chemicals and fire, David applies the liquid with a brush to the heated bronze. Going back and forth between chemical and heat is what creates the patina.

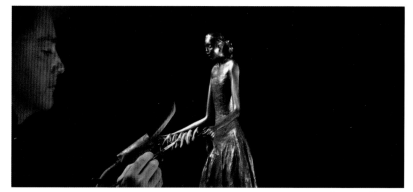

all photos: addison doty

WHAT MAKES DAVID PEARSON'S SCULPTURES UNIQUE
After decades of experience, David has a very unique vision for his patinas. In the beginning, while sculpting the original out of clay he visualizes how the patina will be. Different surfaces from smooth to textured will accept different chemicals. The knowledge of what will work best is something only years of experience can offer, and one only receives such an education after decades of work in the foundries. David is considered by many in the casting profession a patina master.

It is his dedication to excellence–being involved in every step of the process that takes his work to a higher level. He works on every wax, making sure every detail down to the ears and the eyelids is perfect. He finish chases every bronze to make sure the skin areas and textured areas are perfect. He patinas every single piece in every edition to make sure it is exact! He is hands-on with every bronze, which is extremely rare among sculptors.

This is what makes each and every David Pearson bronze sculpture so superior in quality and excellence. His work is not run through a factory process. Every piece is individually created by him, for each special client. And this explains the two to three month casting process. Each piece in his very small editions, (ranging from nine to 15 and never greater than 15) is created individually for the client!

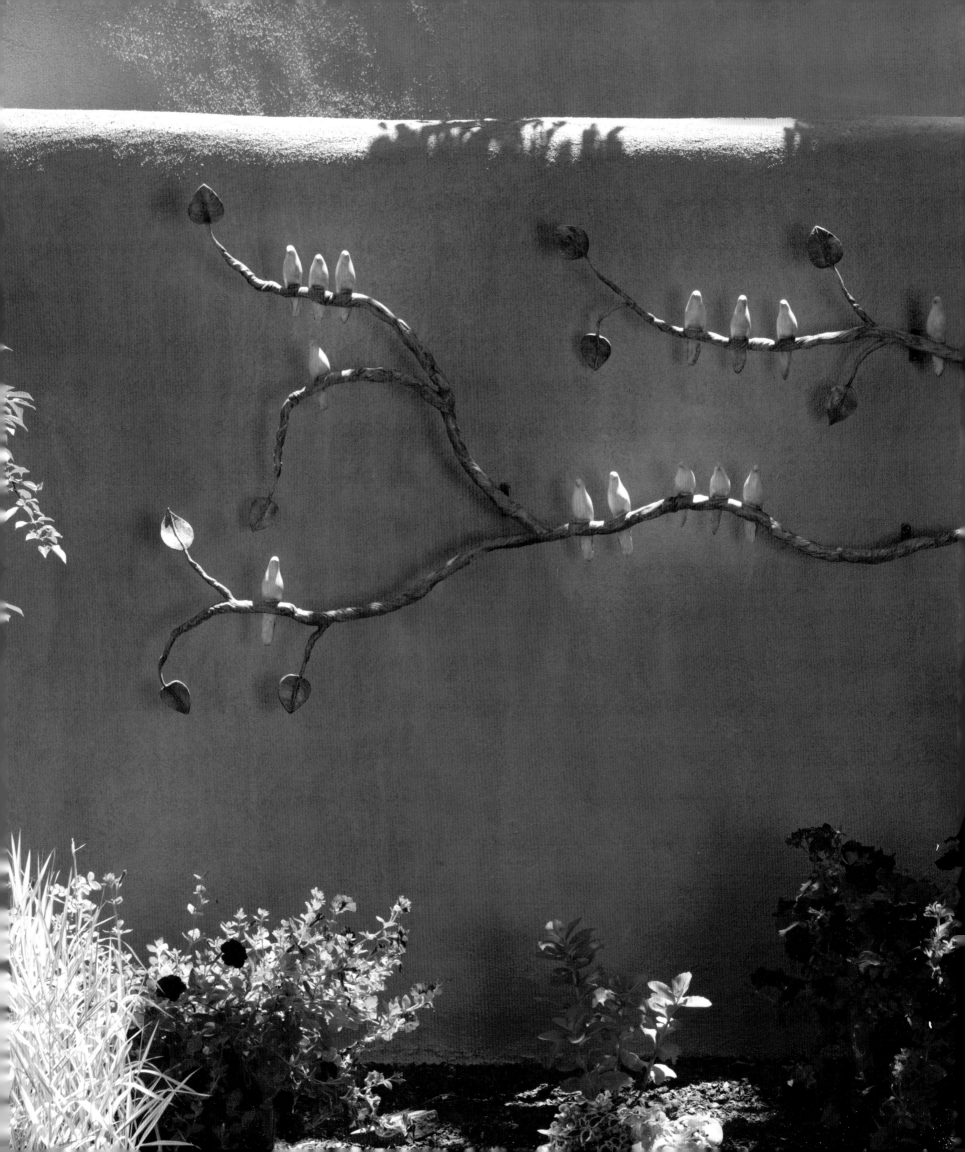

c h a p t e r 7 **the uniques**

*B*y the year 2000, Santa Fe's population had grown to 79,000, while sprawling Santa Fe County held 129,000 residents. Santa Fe had had its first woman mayor—Debbie Jaramillo, known for her occasional outbursts decrying "outsiders" and safeguarding a "Santa Fe for Santa Feans"—and the always art-driven city was experiencing an upsurge in contemporary art, particularly abstraction, minimalism, sculpture, mixed media, and conceptual works. Contemporary art and modernism have been part of Santa Fe's art scene since painter John Sloan began summering here in 1919, and modernist Raymond Jonson taught for decades at the University of New Mexico, but now Canyon Road was changing: it was embracing ever more innovative concepts, with gallery owners estimating that contemporary art was controlling almost a third of the wall space at Santa Fe's 200-plus galleries.

At his studio south of town, David Pearson started experimenting with unique sculptures—original one-of-a-kind works with found objects and often created of mixed media. These became known as "the uniques."

By now Pearson was settling into the ritual of an annual September show at Patricia Carlisle Fine Art—a show that roughly coincides with the

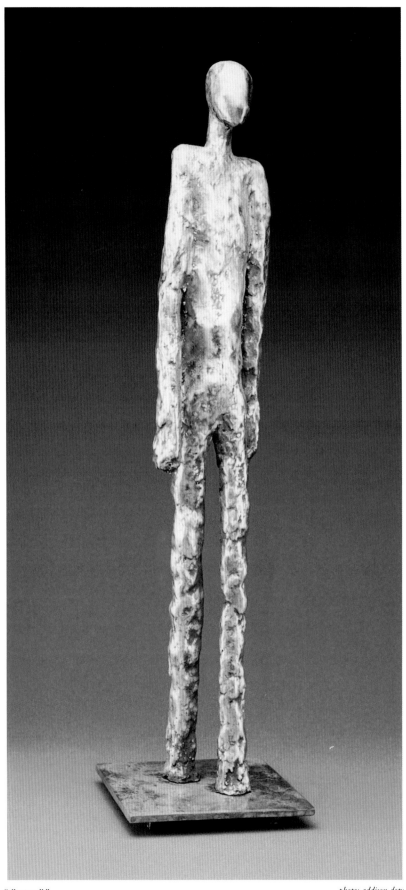

"silent walk"
zinc
24" high
#1/1
© 2000

photo: addison doty

autumnal equinox. New works in bronze statuary are revealed then, as well as throughout the year, with Pearson adamant about editions being limited from nine to 15 pieces.

Also unveiled at his annual show with a significant degree of anticipation are a dozen or so smaller uniques—singular sculptures of a more daring nature. Over the years, these have included sculpted mummies encased in resin with found objects; abstracted walking figures constructed of paper sprayed with metal; unique bronze birds on sculpted branches; sculpted bronze birds on moss rocks; resin plaques with mica and sculpted clay birds; clay mummies with found shells, rocks, and strings, vividly colored with raw pigment on resin;

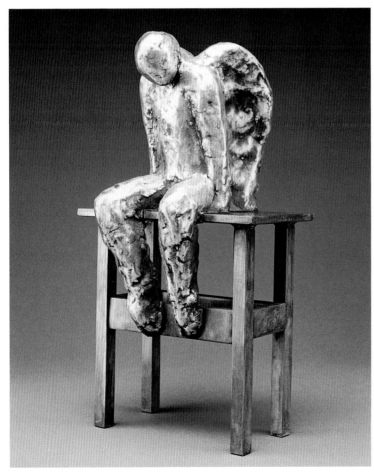

"day's end"
sculpted paper and zinc
13" high
#1/1
© 2000

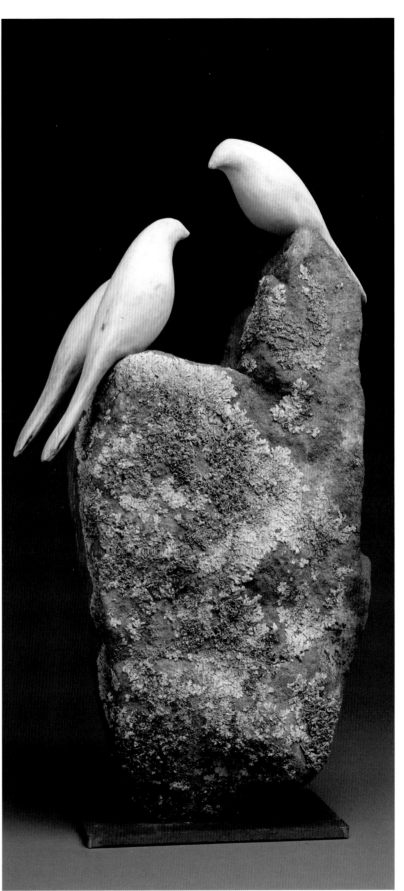

photos: addison doty

"the guru"
bronze and stone
16" high
#1/1
© 2004

gold-leaf mummies with shells; and reliefs using a variety of metals, such as zinc sprayed over paper, copper over paper, and copper over zinc.

Says Pearson, "They're fun. They're different, they're edgy, they're not necessarily my known style. I may sculpt a piece of paper that hardens, then a metal is sprayed over it like aluminum or zinc. One show, I created some mummies and made a box around them and poured clear resin in there, and sealed them in. They can get pretty crazy. The most successful ones are the spray metal over paper. And the birds on the moss rocks. It's a lot more spontaneous."

Because the uniques are experiments, Pearson often "loses" three-quarters of them, deciding that only one-quarter actually work well enough for the show.

The birds are often icebreakers, suggests Pearson. Sometimes considered go-betweens with the spirit world, birds are creatures of the earth but also of the air. In many traditions they are spiritual messengers who move freely between realms. In Pearson's work, there is often no separation between birds and figures, no gulf created by fear. In this way the artist hints at an ideal world, one in which there is no rift between humans and nature. On a more

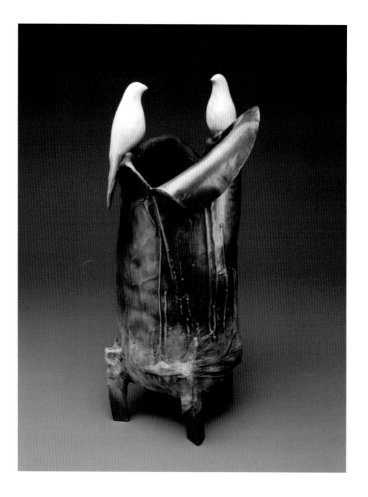

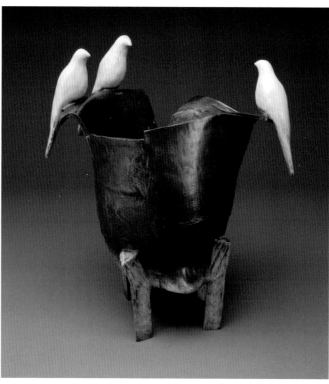

photos: addison doty

unique bronze vessel
18" x 10"
© 2005

unique bronze vessel
16" x 12"
© 2005

literal level, Pearson points out, "Birds take whatever circumstance arises and they go with it, with the same goal in mind—survival."

Longtime Santa Fe painter Jo Basiste observes, "People love David's work. They like the innocence. And the little birds. The pieces that look like mummies that are wrapped remind people of death— but without the sting, they're kind of peaceful."

The uniques are among Pearson's most imaginative envoys from more spiritual realms—"a corner of the creation seen through a temperament," as Emile Zola once said of artworks that resonate.

"on the rock"
resin and mixed media
12" x 12"
#1/1
© 2005

"another time"
resin and mixed media
12" x 12"
#1/1
© 2005

"the journey"
resin and mixed media
12" x 12"
#1/1
© 2005

photos: addison doty

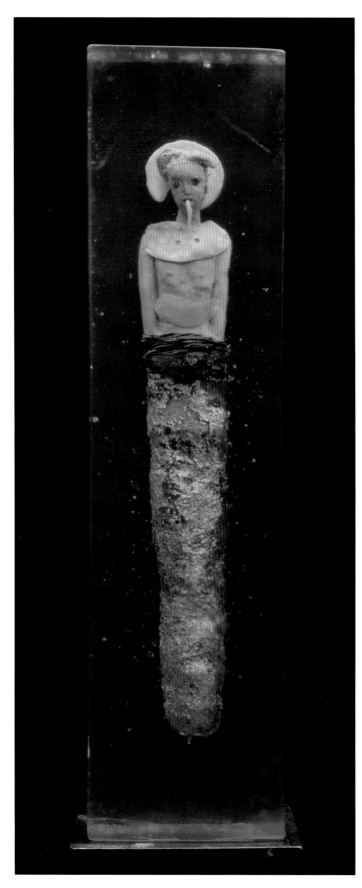

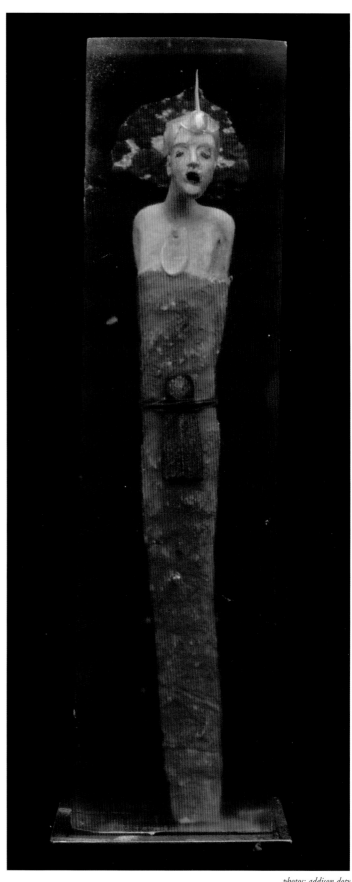

"prince golden boy"
resin and mixed media
61" including steel pedestal
#1/1
© 2005

"lord blue tongue"
resin and mixed media
61" including steel pedestal
#1/1
© 2005

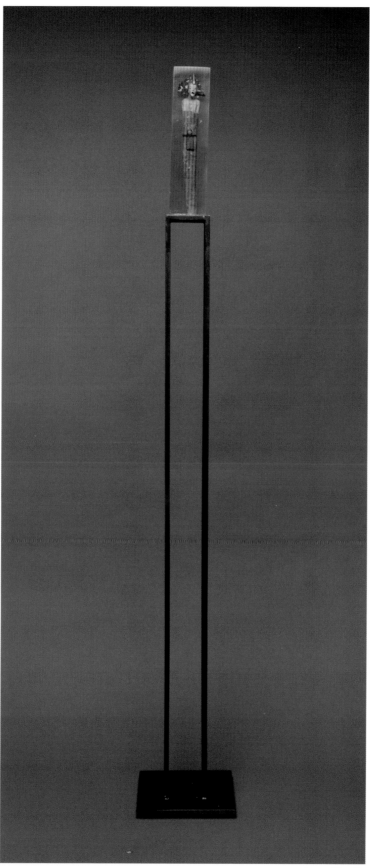

photo: addison doty

c h a p t e r 8 **the mysteries**

photo: jim alford

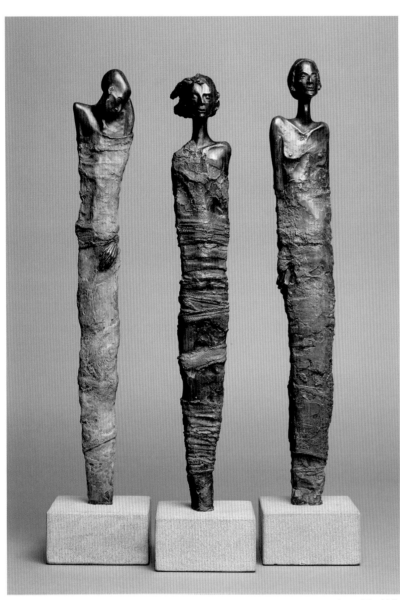

"mummies I, II, III"
bronze
19" high
edition of 15
© 1985

*I*n Dante's "The First Three Circles of Hell," a seeker becomes lost in a forest: "Midway this way of life we're bound upon/I woke to find myself in a dark wood/Where the right road was wholly lost and gone," the poet begins his early 14th century classic. Encounters with a leopard, lion, and wolf ensue on his transformative journey.

Dante is an author whom Pearson often consults as inspiration for his artworks, where mythic forces of nature, spirituality, and mystery deepen the intent. "Transcend" is Pearson's title for an elongated sculpted figure reaching skyward. "Sanscrit" for one that is shrouded. "May Dance" for three female forms circling a tree, and "Dawn" for a half-woman, half-bird with a cloak of solitude. A female figure with a crown of birds is entitled "Saint Fe," and seven white finches are called "Seven Angels."

"Nature is really a secretive teacher," says Pearson. "All the secrets of life are in nature. If you understood nature, you'd be there. I'm also interested in a wide range of occult sciences and religions." For instance, the numbers three, seven, nine, and twelve often have spiritual significance and Pearson's sculptures frequently contain this many figures or birds. "Three's the trinity," he points out. "The number seven is a very universal number. It symbolizes a lot of different things. Peter talks about it in Revelations and he sees the seven candles, seven churches, seven stars. These are like the seven chakras in your body." The number nine is the most magical number, says Pearson: "Nine is where the universe comes together. Everything comes back to nine. The distance of the earth to the sun, everything is nine." As for twelve, "It's the twelve months of the year."

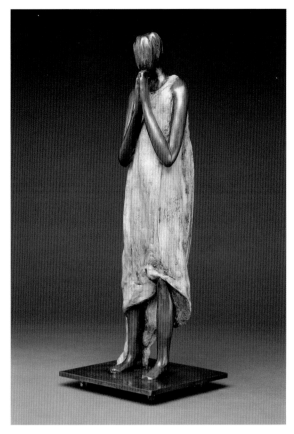

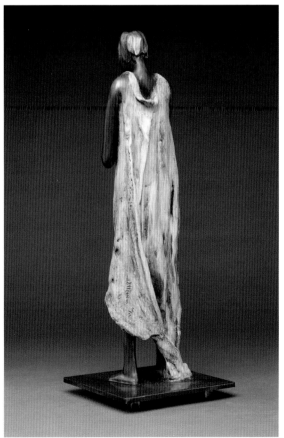

"little swami"
bronze
17" high
edition of 15
© 2002

Always, Pearson is trying to tap into some deeper knowing in his art so that, "When a person looks at the art, they stop for a minute, look at it, and maybe reflect on their life. That's what my art is all about."

Elongation of the figure is the prominent feature of his work, resulting in an abstraction that serves to emphasize the archetypal nature of his figures. It conveys the perception that these are symbolic beings who represent ideas, qualities, and states of mind. According to Charlotte Berney, arts editor at *Cowboys & Indians* magazine, "An elongated figure speaks to the observer on a subconscious plane, suggesting an absence of corporeality and thus a heightened spirituality. Pearson's beings seem to personify the unseen realm of guardians, angels, and spirits."

Some art writers have surmised that Pearson is consciously collecting positive energies in his sculptures—energies that can then flow out again into the awareness of the viewer. "Good energy is the only way to go. We already have enough bad energy working in this world. I'm totally on the good energy side," responds Pearson, who counts among his influences Modigliani ("One of the greats"), Picasso ("His attitude was different"), and Archipenko ("He had some great ideas").

The international art consultant Stephen Saunders notes, "Pearson's sculptures do not borrow stylistically from anyone, yet their intuitive essence corresponds on a peer level with Nefertiti, Gothic cathedrals, the Russian icons, and their artistic heirs: Vermeer, Archipenko, Braque, and Giacometti." Saunders adds, "All of Pearson's works have a common thread of reserve, grace, and depth."

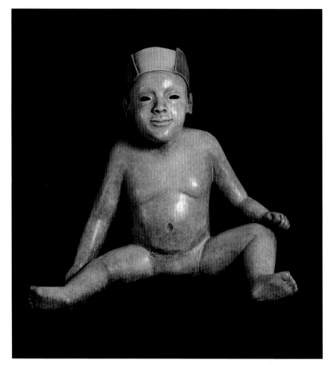

"baby buddha"
bronze
17" x 18" x 10"
edition of 7
© 1997

photo: peter kahn

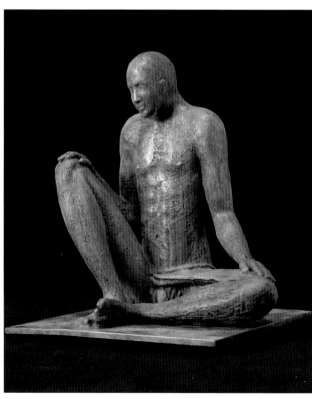

"faith"
bronze
15" x 14"
edition of 9
© 1999

photo: peter kahn

Writing in *Focus/Santa Fe*, Wolfgang Mabry proposes of the artist, "He uses drapery as a metaphor for smoke, which is itself a metaphor for prayer made visible. Pearson expresses things that are intangible and often ephemeral in the paradoxical solidity and permanence of bronze."

To deepen his spiritual awareness, Pearson reads such theosophical books as the bestseller *At the Feet of the Master* by Alcyone (Krishnamurti), who advises, "You must study deeply the hidden laws of Nature, and when you know them arrange your life according to them, using always reason and common sense," and, "Use your thought power every day for good purposes; be a force in the direction of evolution."

Centuries-old Hermetic philosophy from Egypt—and its offshoots, the occult, astrology, and alchemy—about the inter-connectedness of all things, have all been studied by Pearson. So has the work of Swami Sri Yukteswar, who suggested that a synthesis of the spiritual heritage of the East with the science and technology of the West would help assuage the material, spiritual, and psychological suffering of the modern world. Another Pearson favorite is "The Way of Hermes," a meditation on harmony and the divine that is a fusion of Greek and Egyptian thought, including the Stoic philosopher Posidonius's supposition that the cosmos is dominated by the "sympathy of all things," i.e., the stars and events on earth. Avatars—or divine incarnations in human form—are also significant in Pearson's work.

Perhaps Pearson's desire to grasp the life force in all its complexity traces back to his birth on the fall equinox, a time

to honor the mysteries and such goddesses as Persephone, the Muses, and Morgan, such gods as Mabon, Thor, and Hermes. Certainly this reflective occasion—characterized by such stones as sapphires and yellow agates—marks the inevitable beginning of shorter days and longer nights, when the earth will sleep until the sun is again summoned from the dark. It is a time of the year for Pearson to retreat into his studio and his art as Santa Fe itself quiets under the snowfalls that begin in late October.

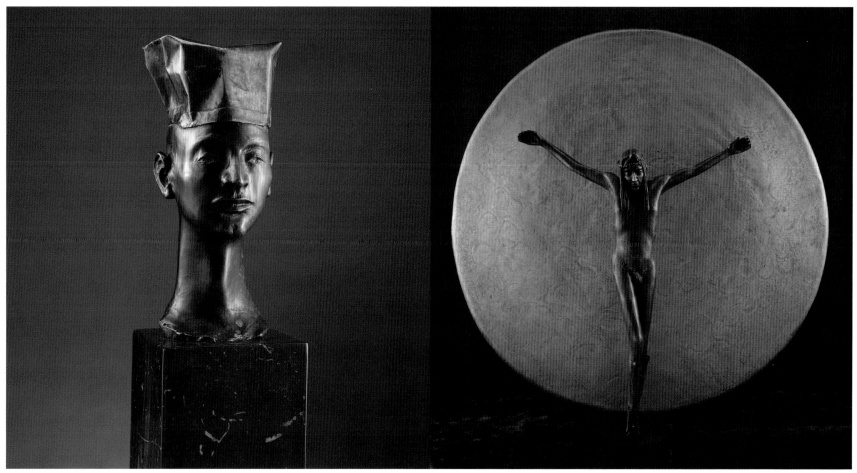

photo: david hoptman *photo: david hoptman*

"beggar's king"
bronze
9" x 4" x 4"
edition of 9
© 1993

"j.c."
bronze
17" x 12"
edition of 15
© 1996

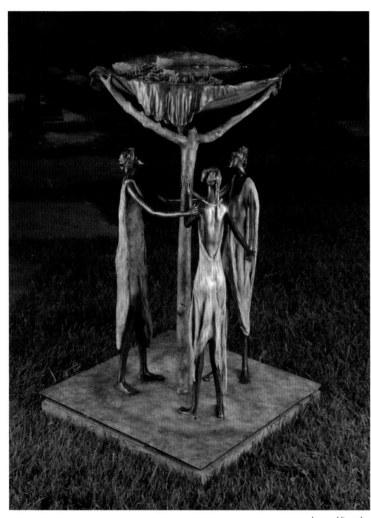

photo: addison doty

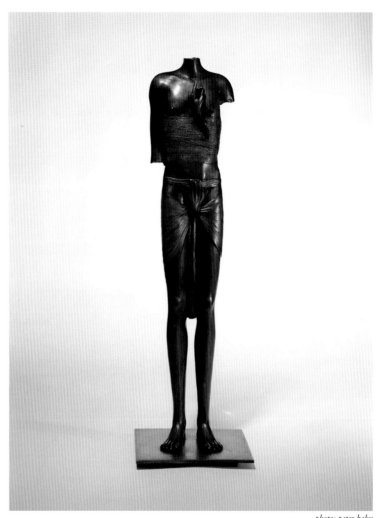

photo: peter kahn

"maydance"
bronze
38" x 24" x 24"
edition of 9
© 2003

"antiquities"
bronze
31" high
edition of 12
© 1997

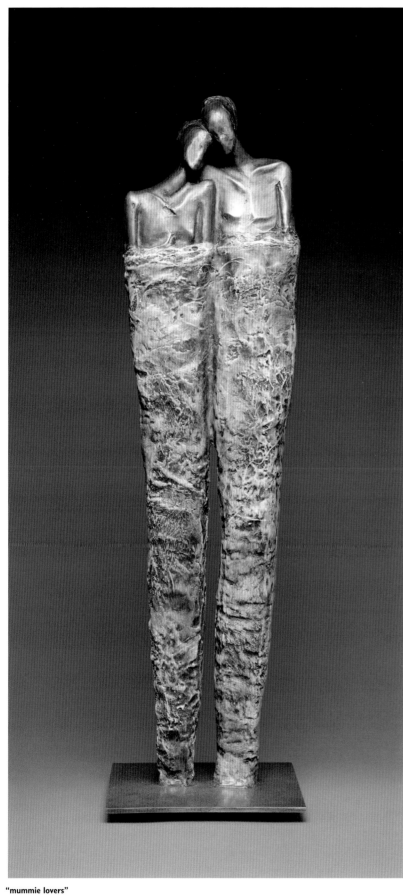

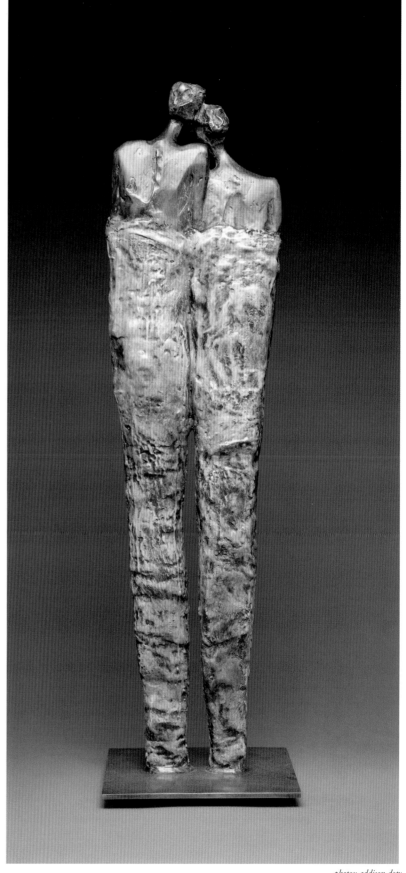

"mummie lovers"
bronze
32" high
edition of 9
© 2001

photos: addison doty

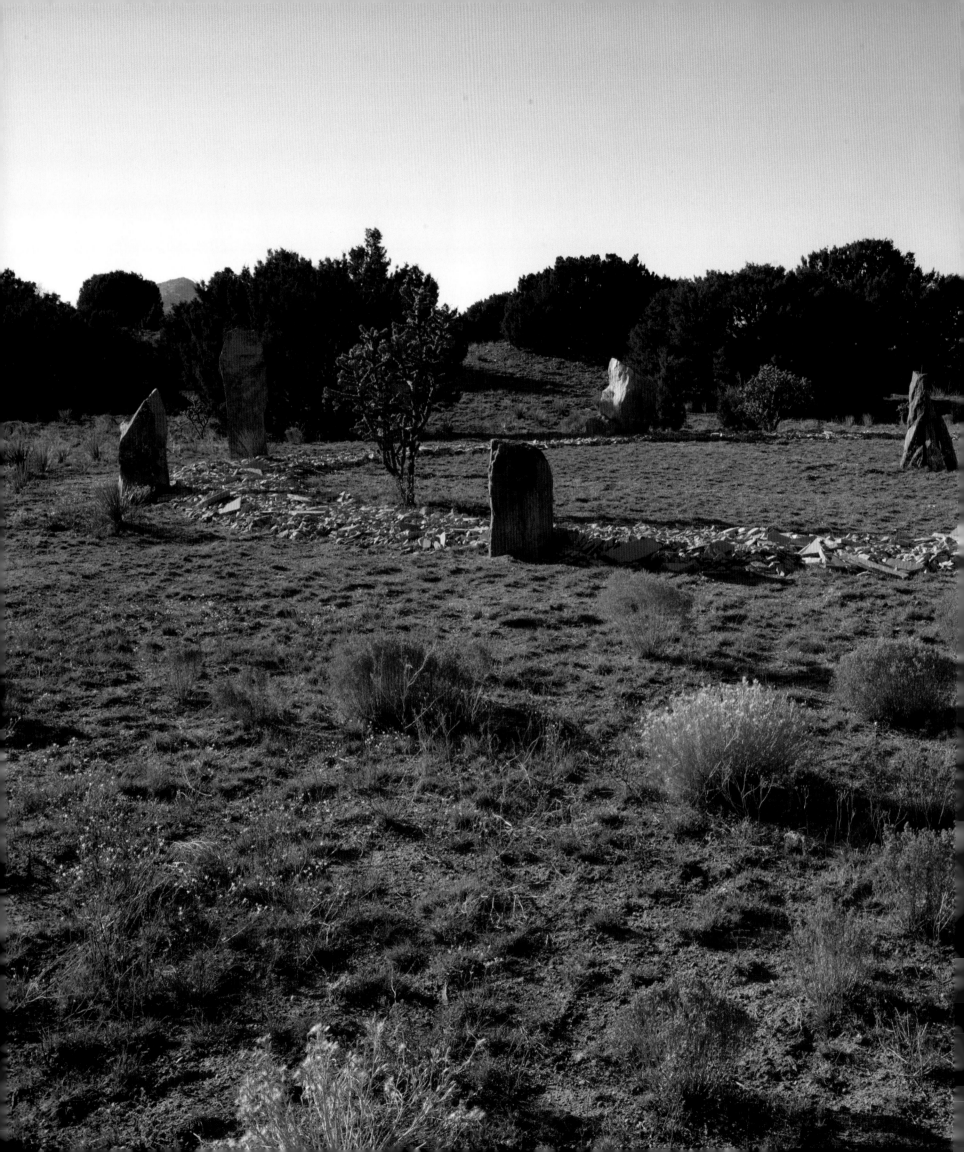

chapter 9 **a realm of his own**

photo: addison doty

"What the teachings say is, 'Look at yourself, go into yourself, inquire into what is there, understand it, go beyond it,'" said Jiddu Krishnamurti, who's drawn such fans as David Pearson and Aldous Huxley to his philosophies of truth, compassion, transformation, and intelligence—and who visited New Mexico to speak of such.

Santa Fe's inspirational qualities have appealed to artists, writers, musicians, and creative souls of all stripes for centuries. "A sojourn to Northern New Mexico has proved to be a turning point for some of the most creative minds of the 20th century," pointed out Hanne Blank in the *Santa Fean* in 2002. Legendary artists have abounded—from Sheldon Parsons, Marsden Hartley, Gerald Cassidy, and John Sloan to Georgia O'Keeffe, Fritz Scholder, Allan Houser, and Bruce Nauman. Author Willa Cather's 1927 book *Death Comes for the Archbishop* drew on Santa Fe lore, D.H. Lawrence ranched in northern New Mexico, and Aldous Huxley's 1925-26 visits fueled his *Brave New World*. Visits to the area sparked spiritual insights for musicians from Igor Stravinsky to Jim Morrison (who believed the souls of one or more Indians killed in a highway accident he witnessed as a child entered his own young body), and photographer Ansel Adams "fell quickly under the spell of the astonishing New Mexico light," as he would later say.

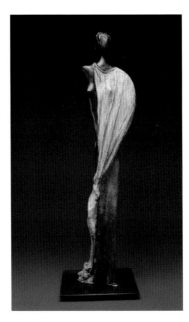

"ananda"
bronze
30" high
edition of 15
© 2002

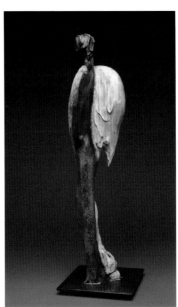

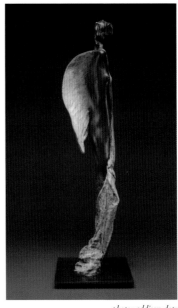

photo: addison doty

By 2005, Santa Fe real estate was so popular that home prices were comparable to those in Boston, Massachusetts, with the median cost of a Santa Fe home reaching $393,000. Both *Travel and Leisure* and *Conde Nast Traveler* were consistently ranking Santa Fe in their top 10 travel destinations. It was still an arts town: according to a study commissioned by the McCune Charitable Foundation, one out of every six workers in Santa Fe County was employed by the arts and culture industry, and in no other city did artists comprise such a large sector of the workforce. But the town was turning more urban.

Down along the Turquoise Trail where Pearson and Carlisle were adding on to their home, it was more like the old Santa Fe. This was still horse country, with plenty of backyard stables like theirs, where their three horses (quarter horse Buck and two Peruvian Pasofinos Porsilana and Ramon del Sol) stuck their heads inquisitively from their stalls. Five large dogs roamed the ranch (three Great Danes— Katie, Blue, and Nessie; an Australian shepherd named Kick; and a Great Pyrenees called Teva) and a cat (Scooter) stood her ground in their midst.

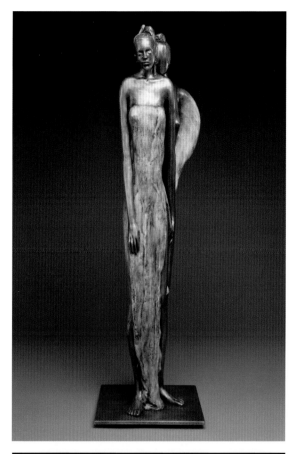

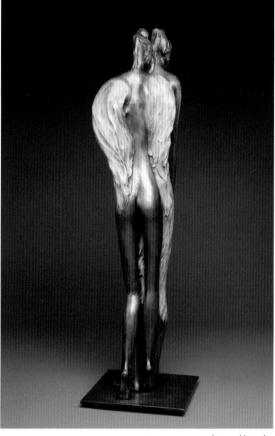

"presence of an angel"
bronze
30" high
edition of 15
© 2005

photos: addison doty

Now 47, Pearson was deeply rooted in his environment. The serene rhythm of things around him merged into his art: "We get up by six, and we're outside by six-thirty. We feed all the animals, including the horses. Patty starts getting ready for work and I get in my truck and drive down the road to the Lone Butte Café and get coffee. Then I come back and get to work," is Pearson's daily routine. He creates nine or 10 new bronze pieces a year, each standing from 30 inches to six-feet tall. Editions are limited to 15 or fewer.

Pearson is currently building onto his 1,500-square foot home, and has planted aspen, apricot, peach, maple, and locust trees to complement the cactus, sage, and juniper. A major project in the works is his concept to replicate an astronomically accurate, Stonehenge-like arrangement of rocks on the property, for rejoicing in the equinoxes and solstices. "That's my church for the universe, the clockwork of the universe," Pearson declared. "It's a way to connect with that energy, and with the fall equinox when I was born."

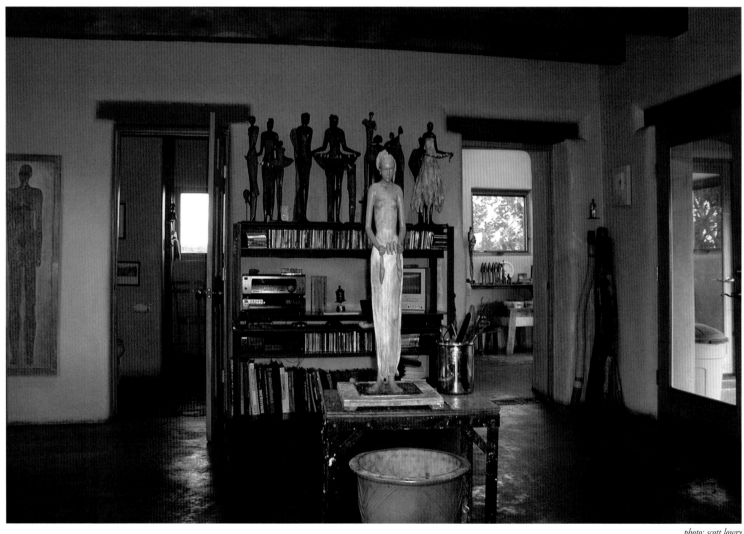

photo: scott lowry

He has constructed two studios at his ranch—a small 500-square-foot space for creating hot waxes and the uniques ("the messy studio"), and a larger 1,200-square-foot space ("the clean studio") built of adobe, for uninterrupted sculpting, metal finishing, and patinas. Outside the studio's windows, birds are alight on the rocks looking for the birdseed that Pearson sets out daily.

"Viewing his habitat is like nudging open a door into the creative machinery of his soul," observed Gussie Fauntleroy in *Focus/Santa Fe* after she visited. "All around us, the artist's 20-acre property is studded with juniper, cactus, and sage. A bright, compact oasis of shade trees and grass lies within a curved adobe wall beside the house. A small stone fountain cools the spirits, and moss rocks with natural pockets hold rainwater for the many songbirds who also call this place home."

The birds were showing up regularly in Pearson's ethereal sculptures—in such pieces as "Seven Angels", "Summer", "Destiny", and "Harmony." The hallmark of a Pearson sculpture, though, remained the elongated figures—creating the psychological effect that the figures are moving between heaven and earth, either ascending or descending, or perhaps inhabiting both regions at once. Because they are not fully parallel to human existence, the figures have an unattainable quality which adds to their mystery. The Greeks were the first culture to develop a strong aesthetic based on the human form as the apogee of perfection, and their world view emphasized the balance between human beings and nature. Likewise, Pearson's figures embody the sublime. The gestalt of a Pearson sculpture is one of harmonious presence and a statement that peace is possible.

"He endows inanimate objects with life and color," observes international art consultant Steve Saunders. "Although he's lived all of his life in New Mexico, his style is universal. Some of his most loyal customers are Japanese. His work is equally at home in Santa Fe as in London or New York or Tokyo. You meet him and he's a real country boy, but he has a style that's really unique and sophisticated."

Now the best-selling artist at Patricia Carlisle Fine Art, Pearson sells more than a hundred pieces a year, with prices ranging from $600 from a small artwork up to $35,000 for a life-sized sculpture. Carlisle points out, "He can sculpt in abstraction, but he also sculpts realism. Most sculptors can't do both. And he does the sculpting, the waxwork, and the patina—that's in contrast to 99 percent of sculptors who take the clay and drop it off at a foundry. They don't see the process through themselves. That's what makes the difference in a Pearson bronze. Quality control is essential!" As for the mini ranchito—"When we bought this property it was just vacant land. Now it's our sanctuary. We've created a little slice of paradise."

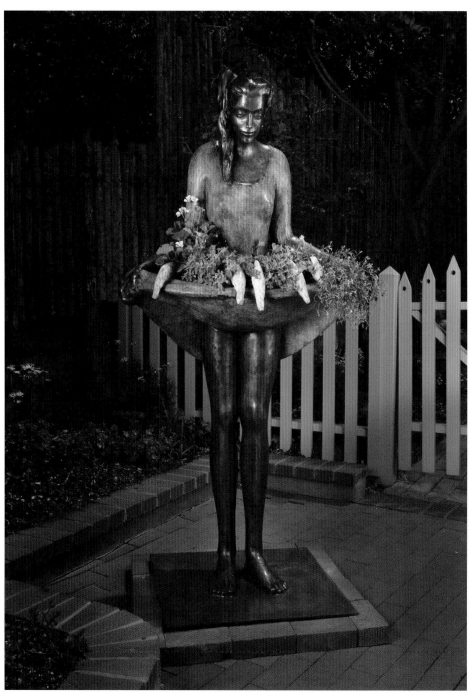

photo: addison doty

"summer"
bronze
5' 8" high
edition of 12
© 2002

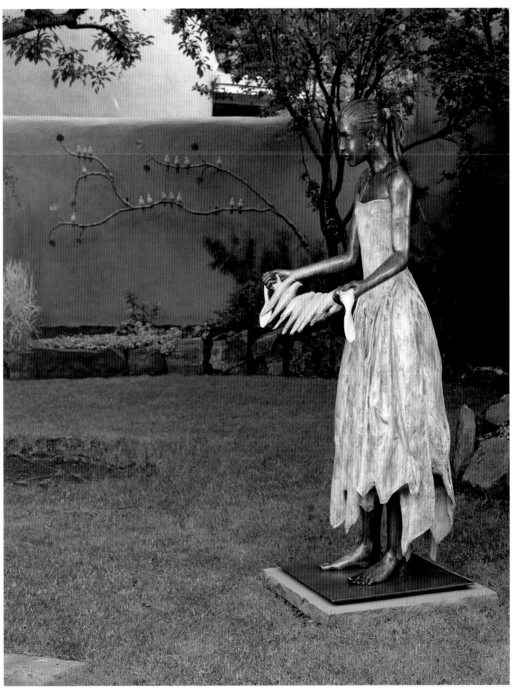

photo: addison doty

"meeting at midday"
bronze
8' long
1/1
© 2005

"song of songs"
bronze
5'2" high
edition of 15
© 2005

Most of Pearson's larger works were being cast at Shidoni, bringing him full circle to where he started out. Shidoni owner Tommy Hicks discerns, "The craftsmanship is good and there's a dedication to it. He's very prolific, very consistent. You can go into a gallery and say, 'Hey, that's a Dave Pearson.' Which is good. He takes that idea he has all the way through as far as he can."

His old Shidoni colleague Doug Coffin reflects, "Dave figured out you learn the basics, and you do it one step at a time improving on what you choose to do. The rest of the things fall into place if you do it long enough and right enough. What he's done better than anybody else is make it 100 percent on his own terms, his own effort—nobody's opened any doors for him other than himself."

In writing this book, I was lucky enough to be enfolded in a Santa Fe art circle including David Pearson, Tommy Hicks, Doug Coffin, Jo Basiste, Terry Allen, and Patricia Carlisle. I was privileged to hear their insider perceptions of Santa Fe's changing art life—from the commune-like days of the seventies when artists still lived cheaply clustered in compounds on Canyon Road and played pool at the Shidoni bar, to the Indian art heyday of the eighties, to the current boom in contemporary art. What resonated most for me was the effect Santa Fe had on them all—as Coffin observed, the synchronicity of being "the right person at the right place at the right time with creativity."

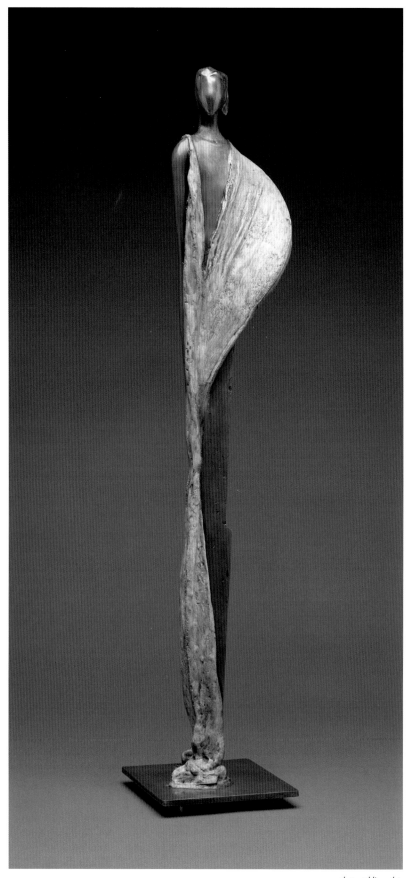

photo: addison doty

"le jeune saint"
bronze
30" high
edition of 15
© 2005

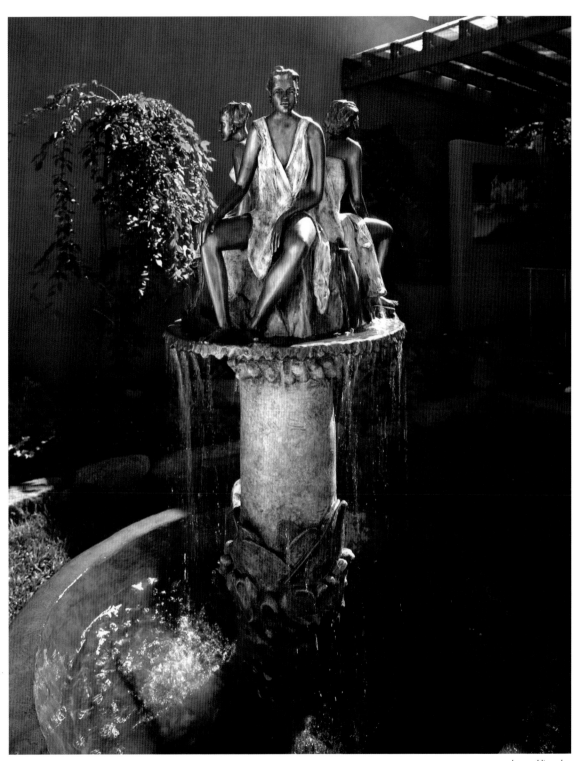

Now in 2006 as Pearson goes forward into the 21st century, he says, "I just want to continue on the path I've started on. My path is about connecting with people and bringing out emotion. I'm very set on this direction. From the very beginning, it's been a steady course." He's finally living the life he always wanted for himself—and it's pretty much what he imagined it would be. "The hardest part of my work is making deadlines. The easiest part is just lovin' what I do," says the quiet-spoken artist over a glass of red wine. He motions out the windows of his studio. We look at the sun-splattered setting that invokes possibility with its scattered trees under huge cornflower skies, the large dogs trotting by hardy flower beds. It's an uncluttered environment of life and art and beauty—with nothing extraneous. "It's like what Frank Herbert wrote in 'Dune,'" says Pearson. "I go forth unto my work like a wild ass in the desert."

"oasis"
bronze
56" x 24" x 24"
edition of 15
© 2002

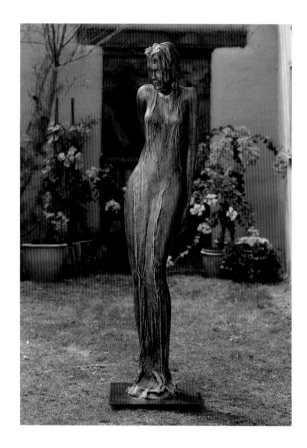

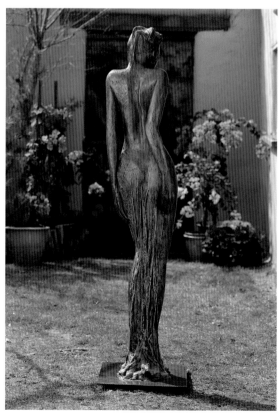

"kamsin"
bronze
5' 10" high
edition of 9
© 2000

photos: robert reck

CHRONOLOGY

DAVID K. PEARSON

BORN: September 20, 1958

EDUCATION / APPRENTICESHIP:

1975-1981 Shidoni Foundry: Apprentice to Fine
Art Casting Method, Lost Wax - Mold
Making, Wax Pattern, Metal Finishing and Patina.

1982-1992 Art Foundry: Director and Master Sculptor.

1992-1995 Casting project for Notre Dame College
football Hall of Fame (700+ reliefs) of
individual coaches and players.

1995-1997 Allan Houser Inc. - Designed and built
Foundry for production of all remaining editions
to be cast in bronze. Patina master and mold
restorer for all remaining editions.

EXHIBITIONS

2006 Patricia Carlisle Fine Art, Santa Fe, NM
2005 Patricia Carlisle Fine Art, Santa Fe, NM
2004 Patricia Carlisle Fine Art, Santa Fe, NM
2003 Museum of the Southwest, Midland, TX
 *Honorable Mention
 Patricia Carlisle Fine Art, Santa Fe, NM
2002 White House Ornament Artist,
 Washington, D.C.
 * Governors Choice

Gateway Museum, Farmington, NM

* Award Winner, National Competition

Patricia Carlisle Fine Art, Santa Fe, NM

2001 Washington Home and Garden Show,

Washington, D.C.

Longview Museum of Fine Art, Longview, TX

Sculpture-in-the-Park Annual Invitational,

Loveland, CO

Albuquerque Museum of Fine Art, "Miniatures 01"

Albuquerque, NM

Patricia Carlisle Fine Art, Santa Fe, NM

2000 "Miniatures 00" Albuquerque Museum of Fine Art

Albuquerque, NM

Patricia Carlisle Fine Art, Santa Fe, NM

One Person Exhibit

1999 "Miniatures 99" Albuquerque Museum, NM

Patricia Carlisle Fine Art, Santa Fe, NM

One Person Exhibit

1998 Patricia Carlisle Fine Art, Santa Fe, NM

One Person Exhibit

1997 Patricia Carlisle Fine Art, Santa Fe, NM

One Person Exhibit

1996 Perry House Gallery, Washington D.C. January

Perry House Gallery, Washington D.C. April

"The Best of Perry House"

1994 Open Studio, Santa Fe, NM. October

Perry House Gallery, Washington D.C.

November

1992 Atherton Gallery, Santa Fe, NM

Saunders International Sculpture Gallery

Washington D.C. November

College of Santa Fe, Santa Fe, NM

1991 One-Person Exhibit, Atherton Gallery,

Santa Fe, NM

Tideline Gallery, Rehoboth Beach, DE

1990 Central Park Gallery, Kansas City, KS

1989 Pacific Enterprises Exhibit, Los Angeles, CA

*Purchased several pieces for collection

1988 American Medallion Sculpture Association,

Janus Gallery, Santa Fe, NM

1987 Jamison Gallery, Santa Fe, NM

1985 Hunter Museum of Art Chattanooga, TN

1983 Scottsdale Center for the Arts, Scottsdale, AZ

1981 College of Santa Fe, Santa Fe, NM

Art Spirit Gallery, Boulder, CO

Midland College, Midland, TX

1979 Shidoni Gallery, Tesuque, NM

Fine Arts Center, Colorado Springs, CO

Lambert Gallery, Dallas, TX

PUBLIC ART COLLECTIONS

2005 City of Edmond, Oklahoma

"Silent Desert"

2004 Los Alamos National Bank, Santa Fe, NM

"Innocence"

2004 Los Alamos National Bank, Santa Fe, NM

"Transcend"

"Rain Song"

2004 Gaston Memorial Hospital, Gastonia, NC

"Finch"

2004 First Commercial Bank, Edmond, OK

"Angelic Being" 5'8" high

2003 St. Luke's Hospital, Woodlands, TX

"Bonsai"

2002	White House Collection
	a unique bronze bird
2002	City of Edmond, Oklahoma
	2 life-size bronzes
2002	Capital Art Collection - New Mexico
	"Love Doves",
1999	Pinnfund, Carlsbad, CA
	1 life-size bronze,
	(1) 40" bronze
1990	Pacific Enterprises, Los Angeles, CA
	(2) 29" bronzes

PUBLIC INSTALLATION PROJECTS

1998	Enlarged Terry Allen's sculpture of "Stubbs", a seven-foot commission in Lubbock, TX
1996	Enlarged, cast, and applied patina for Terry Allen's sculpture, "Golden Time", on top of the Sony Entertainment Astair Building in Los Angeles, CA. Directed and oversaw installation from start to finish.
1990/91	Enlarged, cast, and applied patina for Terry Allen's sculptures which included "Shaking Man" in San Francisco, CA, and "Corporate Head" at Citi-corps Plaza in Los Angeles, CA
1989	Enlarged, cast, applied patina, and installed Ron Cooper's "13' Vessel" in downtown Los Angeles.
1983/84	Enlarged, cast, applied patina, and installed Una Hanbury's sculptures of the Lions as well as the Phoenix Bird at the Albuquerque Zoo

While serving as director of the Art Foundry from 1984 through 1993, David collaborated and sculpted on projects from inception through installation with:

Terry Allen

Kiki Smith

David Salle

Bruce Nauman

Linda Benglis

Win Knolton

Peter Shelton

Chuck Arnoldi

Laddie John-Dill

Ron Cooper

Peter LaDato

Bill Barrett

Allan Houser

Luis Jimenez

Tom Otterness

Fritz Scholder

SELECTED PUBLICATIONS

2005	Honorable Mention *Sculptural Pursuit* Summer issue
2005	*THE Magazine*, Review, October
2003	*Southwest Art*, "7 Sculptors to Watch" July issue
2002	*ARTbook*, "Ethereal Sculptures" Fall/Winter issue
	Pasatiempo, "Earth Angels" October 11th
	Focus Santa Fe, "Cover" June
	Edmond Life & Leisure, "Public Art Unveiled", April 18th
	Edmond Sun, "Age of Innocence" April 14th

	Edmond Sun, "Art in Public", January 27th	1998	*Santa Fean Magazine*, October
2001	*New Mexico Magazine* "The Alan Houser Touch", March		*Focus Santa Fe Magazine*, Oct/Nov/Dec
	Focus Santa Fe, October		*ARTnews*, October
2000	*THE Magazine*, Review, October		*Pasatiempo Arts Magazine*, October 9th
	Focus Santa Fe Magazine, "Cover Feature", June	1997	*Art-Talk*, October
	Southwest Art, "Artists to Watch", February		*Pasatiempo Arts Magazine*, October 19th
	Santa Fe Reporter, "Desiring Good Art", February 9th		*Santa Fean Magazine*, February 6th
1999	*THE Magazine*, October	1994	*Gazette Packet Alexandria Port*, December 22nd
	Focus Santa Fe Magazine, Oct/Nov/Dec	1993	*Pasatiempo Arts Magazine*, May
	ARTnews, September	1992	*Architectural Digest Magazine*, February
			Pasatiempo Arts Magazine, August 7th
		1991	*Delaware Coast Press*, July 17th

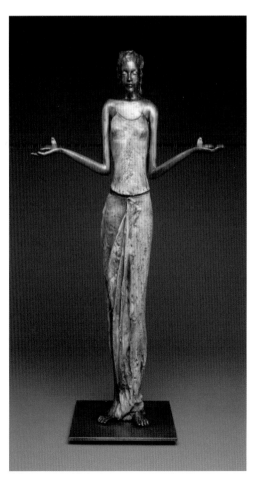 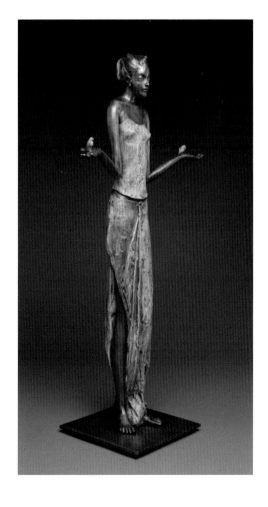 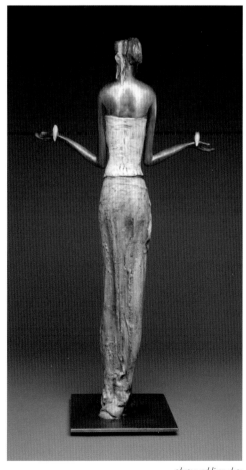

photos: addison doty

"love songs"
bronze
30" high
edition of 15
© 2005